D1174614

Copyright © 2011 Arizona–Sonora Desert Museum

All rights reserved. All text and design copyright by Arizona–Sonora Desert Museum.
All paintings © Edna San Miguel.

First Edition
Published in the United States of America by Arizona–Sonora Desert Museum Press
2021 N. Kinney Road | Tucson, Arizona 85743
www.desertmuseum.org

This book is available at quantity discounts for educational, business, or sales promotional use.
For further information, please contact:
Arizona–Sonora Desert Museum Press
520–883–3028 | asdmpress@desertmuseum.org

Paintings by Edna San Miguel are artistic interpretations of the art and activities of the mission, and colors in these images are not necessarily true, or may be enhanced. On page 48 paintings by San Miguel are mixed with actual photographs.

Las pinturas de Edna San Miguel son interpretaciones artísticas del arte y las actividades en la misión. Los colores de las imágenes pueden no corresponder con los colores reales o estar aumentados. La página 48 incluye tanto pinturas de San Miguel como fotografías.

ISBN: 978-1-886679-43-6
Copyright registered with the U.S. Library of Congress

Book development by Richard C. Brusca and Linda M. Brewer
Edited by Linda M. Brewer
Translated by Ana Lilia Reina-Guerrero
Design by Terry Michelle Moody
Printed in Canada by Friesens

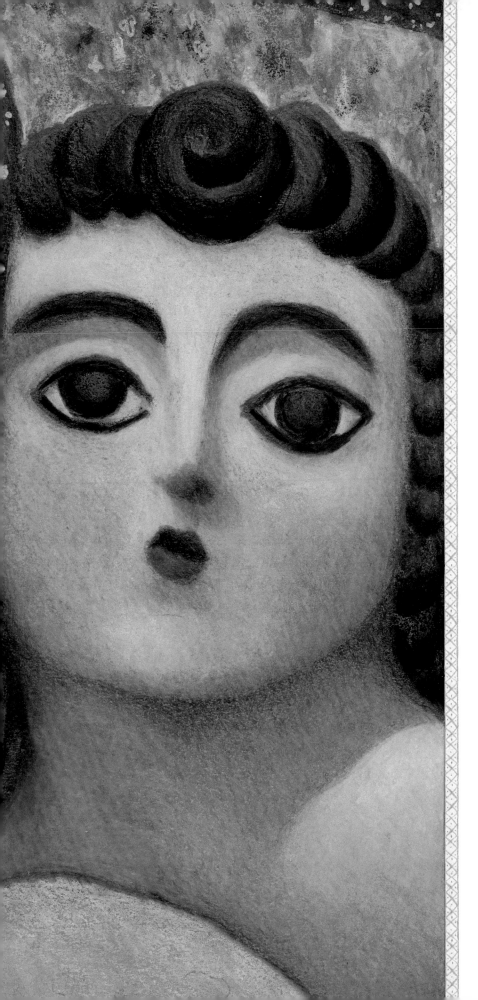

To my children and grandchildren... Anjelica, Richard, Gregory, Christopher, Gabriel, and Ayden. This book is for you. This sharing is for the muse that lives inside each of you.

A mis hijos y nietos... Anjelica, Richard, Gregory, Christopher, Gabriel y Ayden. Este libro es para ti. Lo comparto por la musa que vive dentro de cada uno.

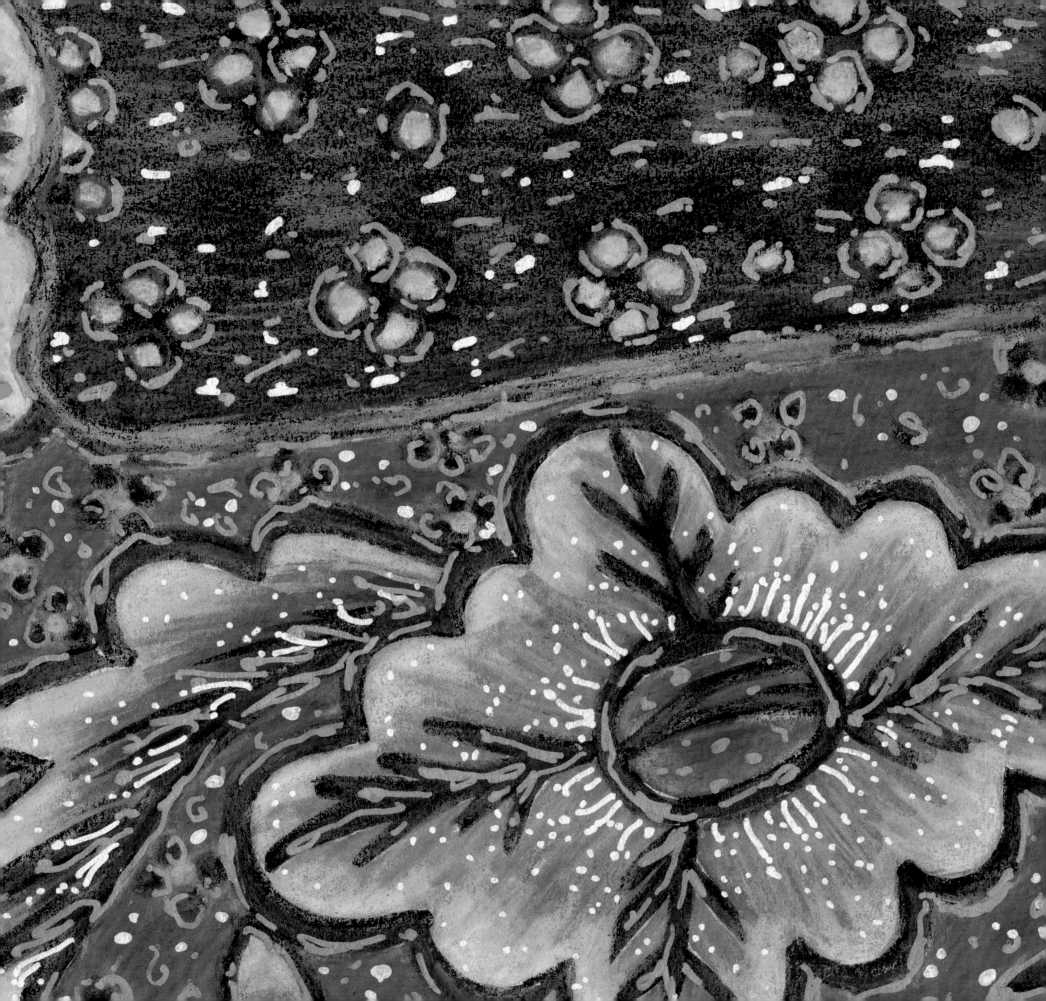

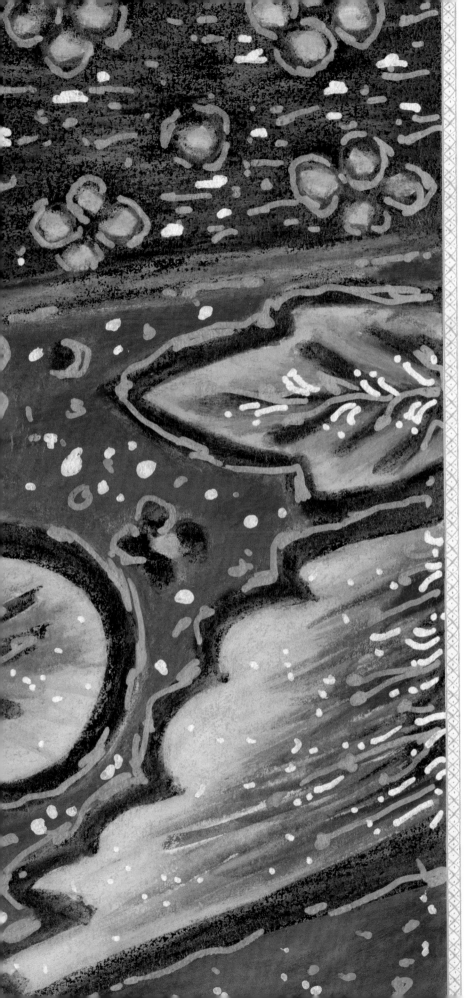

CONTENTS

A STORY OF MISSION SAN XAVIER /

UNA HISTORIA DE LA MISIÓN DE SAN XAVIER

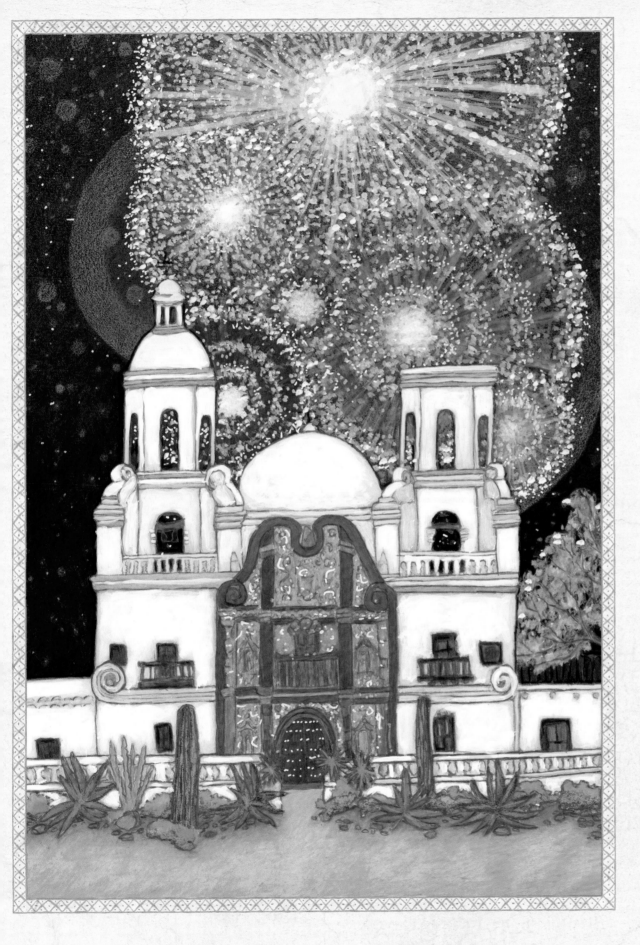

In the desert near Tucson, Arizona, stands a magnificent church. It is part of the Mission San Xavier del Bac. On the outside, the church is white. On the inside, its walls and ceilings glimmer and dazzle in bright rainbow colors and shimmering gold, like the fireworks of the San Xavier festival held at the mission in early December every year.

En el desierto cerca de Tucson hay una iglesia monumental que forma parte de la Misión de San Xavier del Bac. Por fuera la iglesia es blanca. Por dentro sus paredes y techos brillan con los vivos colores del arco iris y sus resplandores dorados, igual que los fuegos artificiales del festival de San Xavier que se realiza en la misión cada año a principios de diciembre.

"Bac," or *Wa:k*, comes from the language of the Tohono O'odham people, who live by the mission and the Santa Cruz River. It means something like "where the waters join with the land."

"Bac" o Wa:k *proviene de la lengua Tohono O'odham de la gente que vive en la misión y en la ribera del río Santa Cruz; significa "donde el agua se junta con la tierra".*

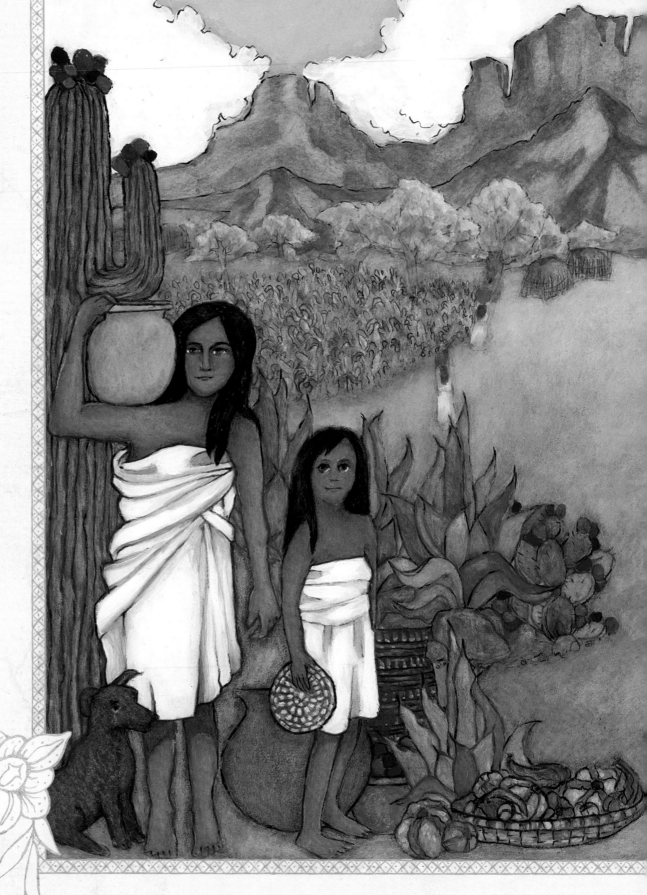

Tohono O'odham villagers raised the "three sisters" crops—native beans, corn, and squash—long before Europeans arrived.

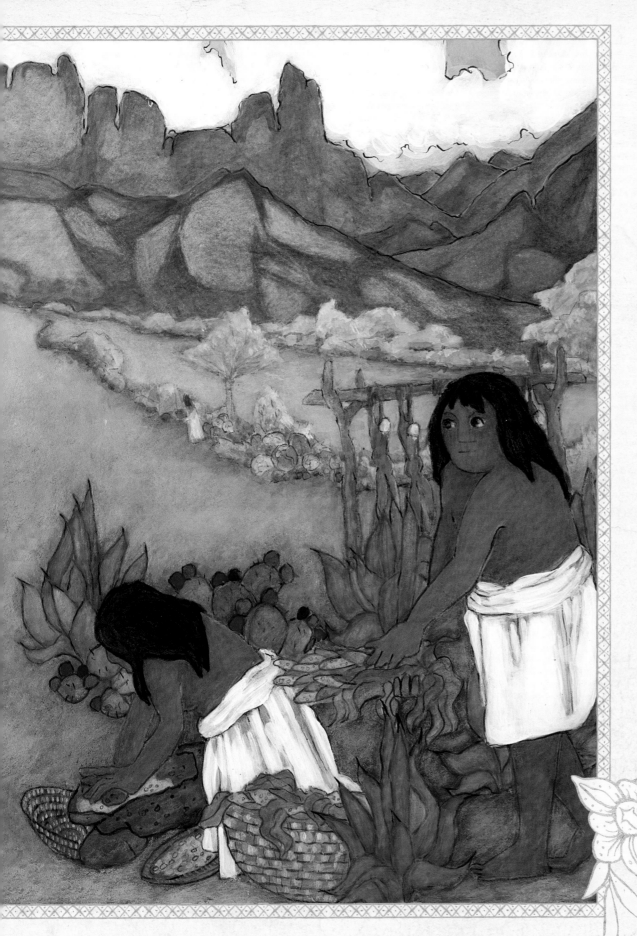

Today, water rarely runs in this river, but in past centuries water rose to the surface nearby and flowed more often over its sands. O'odham villagers used that water to drink and to farm, and the land here looked like a lush oasis.

Actualmente es muy raro que el agua corra en este río, pero en los siglos pasados el agua subía hasta la superficie y seguido inundaba sus arenas. Los habitantes O'odham usaban el agua para beber y para sembrar y la tierra allí lucía como un frondoso oasis.

Los Tohono O'odham sembraban los cultivos "tres hermanos": frijol, maíz y calabaza regionales mucho antes de la llegada de los europeos.

In 1692, Father Eusebio Kino arrived in the village of *Wa:k*. A Jesuit missionary, he wanted to share his faith with the villagers, and he wanted to make their lives easier. He brought cattle they could raise for meat, fruit trees to grow, and new crops like winter wheat. Not all the Indians embraced his new ways and new faith, but many did.

El Padre Kino llegó al pueblo de Wa:k en 1692. Un misionero Jesuita que quería compartir su fe con sus pobladores y mejorar su vida. Llevó ganado que podrían criar para producir carne, árboles frutales para plantar y cultivos nuevos como el trigo de invierno. Aunque no todos los indígenas acogieron su nuevo estilo de vida y fe, muchos lo aceptaron.

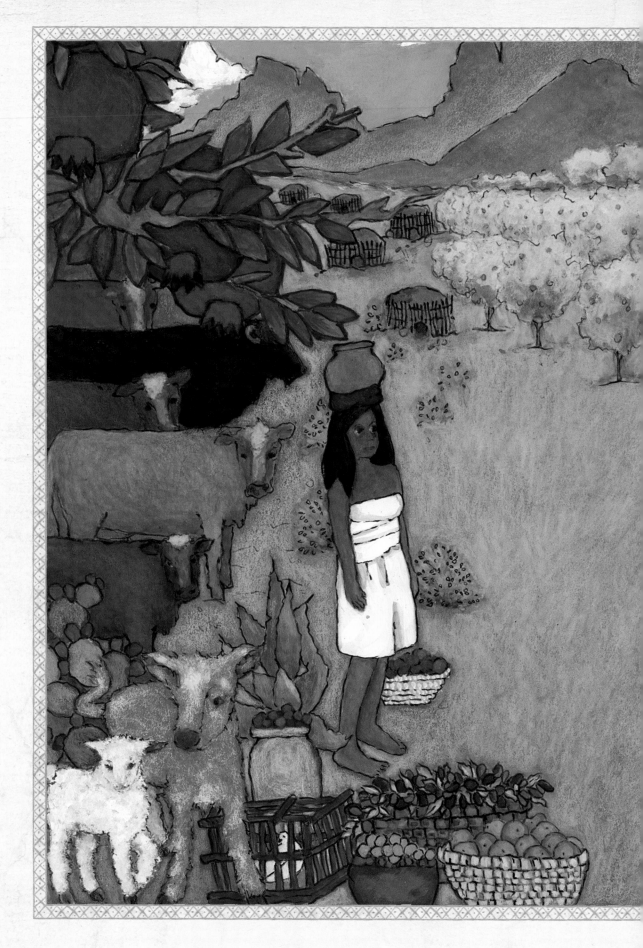

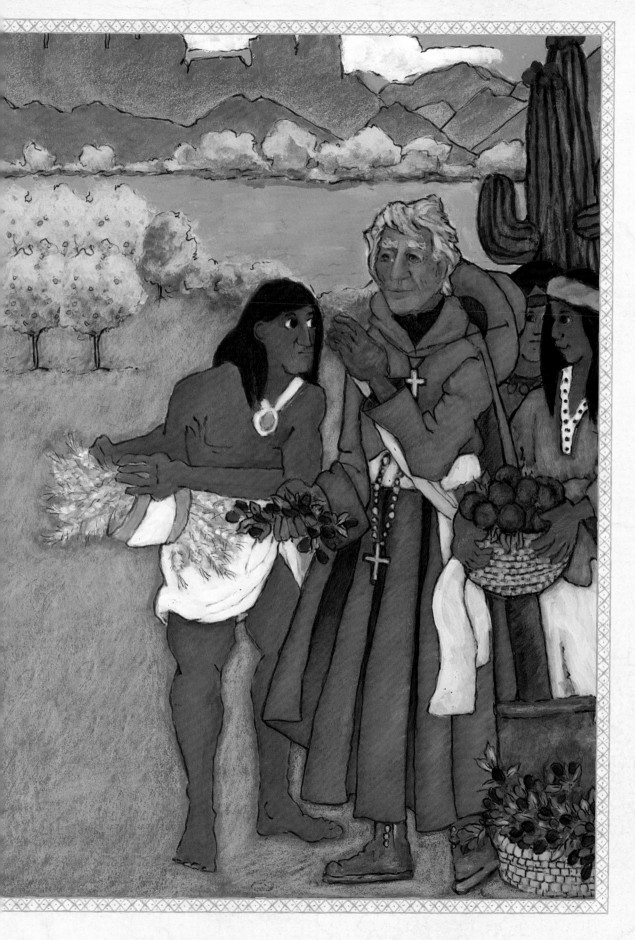

With the help of village workmen, Father Kino and his companions used rocks from the surrounding hills to begin the foundation for a church. That building was never finished, but nearly a hundred years later, other missionaries, builders, and artists began to raise a church out of the earth. Over the decades, it came to be known as the "White Dove of the Desert."

Ayudados por los hombres del pueblo, el Padre Kino y sus acompañantes usaron piedra de los cerros cercanos para poner los cimientos de una iglesia. Ese edificio nunca se terminó, pero casi 100 años después, otros misioneros, constructores y artistas empezaron a levantar una iglesia de la tierra. Algunas décadas después llegó a conocerse como la "Paloma Blanca del Desierto".

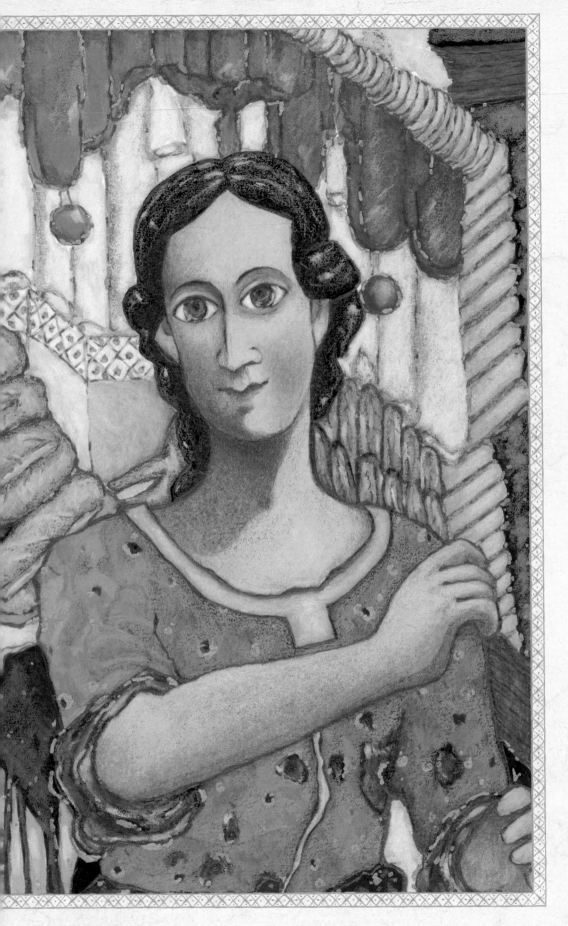

To inspire and uplift the people who worshipped there, artists decorated the walls inside the church with vivid art. Most of the rich pigments —reds, yellows, blues, and greens—were expensive, imported from Mexico or Europe, but a few of the more muted hues may have been gifts of the land, from the rocks and minerals around them. The artists also used real gold and silver leaf.

Los artistas decoraron las paredes dentro de la iglesia con un arte muy vivo para inspirar y alegrar a la gente que vendría a orar a este lugar. La mayoría de los pigmentos de colores intensos: rojos, amarillos, azules y verdes fueron costosos e importados desde México o Europa, pero algunos de los tonos más apagados es probable que fueron regalos de la tierra, provenientes de las rocas y minerales de los alrededores. Los artistas también usaron el dorado con oro y plata reales.

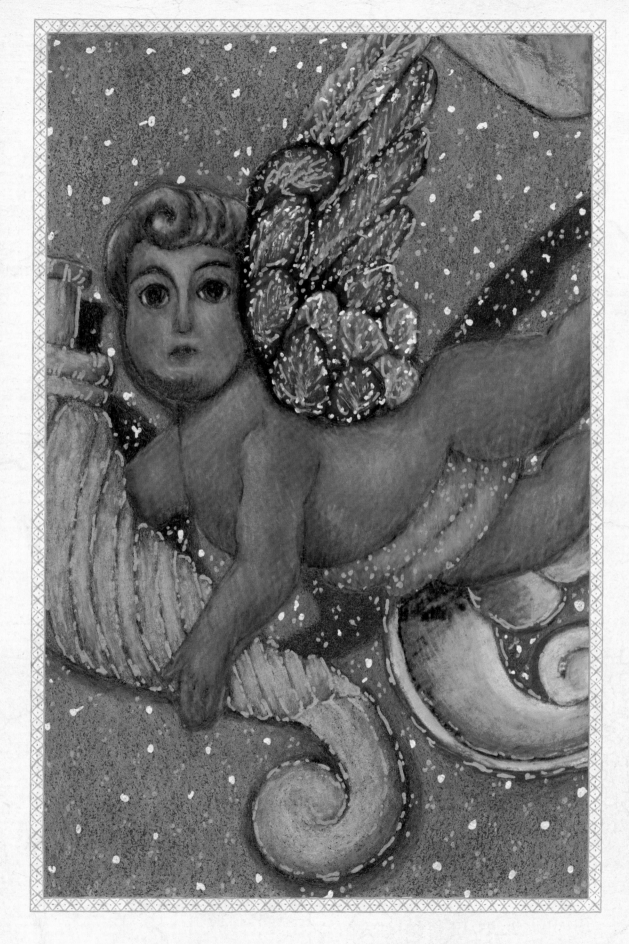

They painted the walls with floral and geometric designs. They also painted murals with scenes from the Bible or scenes from the lives of the saints to help tell their stories to the congregation. They painted many saints and angels, including many round-faced cherubs.

Pintaron las paredes con diseños florales y geométricos. También pintaron murales con imágenes de la Biblia o de la vida de los santos para facilitar contar estas historias a los feligreses. Pintaron muchos santos y ángeles, muchos de ellos querubines de carita redonda.

Altogether, more than 170 angels and dozens of saints decorate the mission, including many made of wood or plaster. There are 55 statues in the church, including Saint Francis of Assisi and Mary as the Immaculate Conception.

Juntos, más de 170 ángeles y docenas de santos decoran la misión, muchos de ellos de madera o yeso. En la iglesia hay 55 estatuas, entre ellas la de San Francisco de Asís y la de La Inmaculada Concepción.

St. Francis of Assisi, Mary as the Immaculate Conception, and a floral decoration on the church ceiling.

San Francisco de Asís, La Inmaculada Concepción y una decoración floral en el techo de la iglesia.

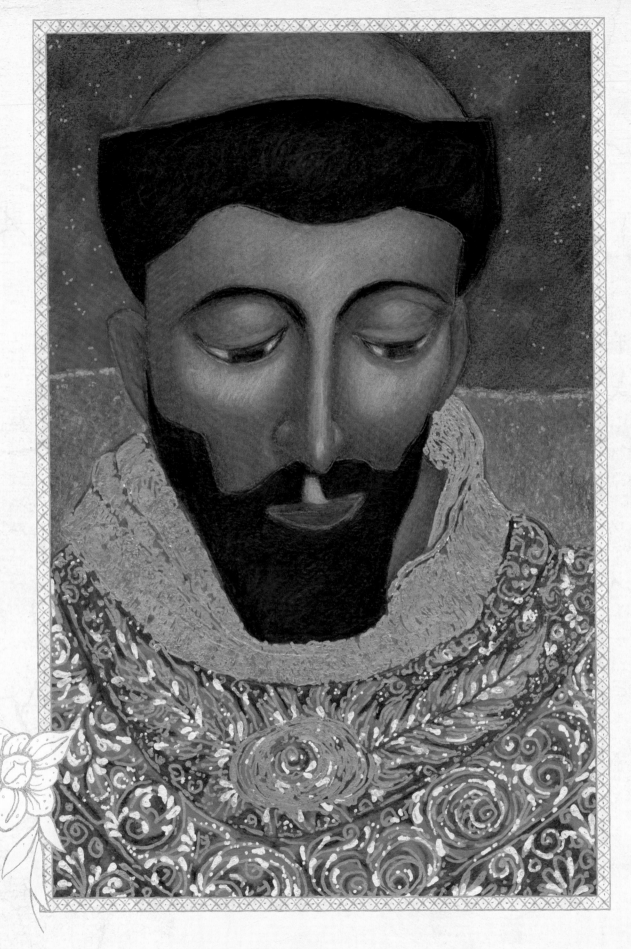

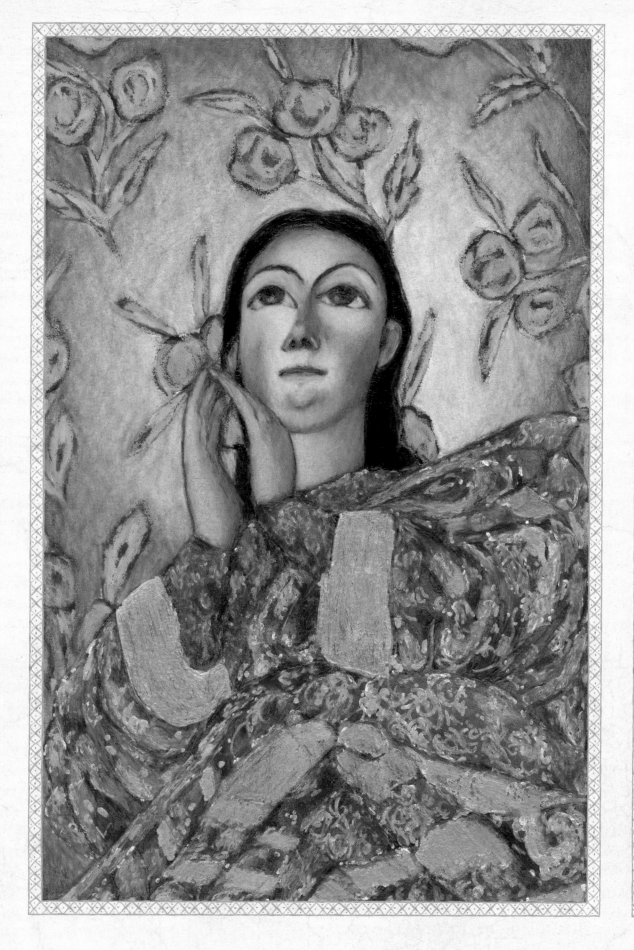

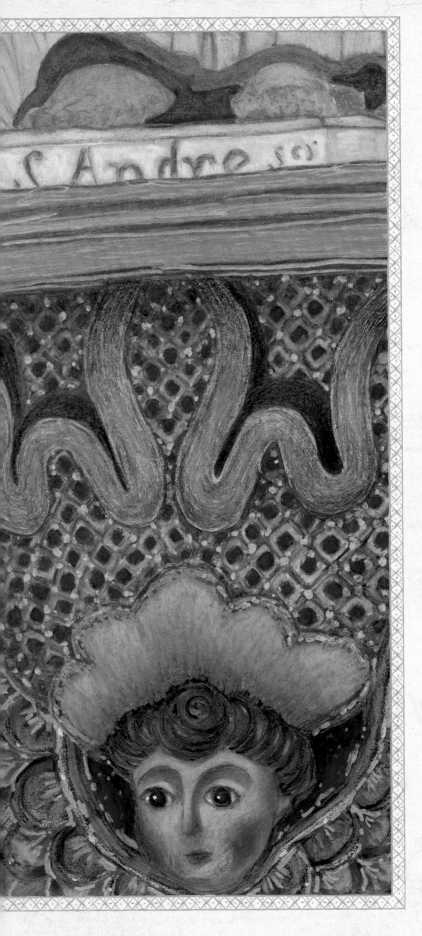

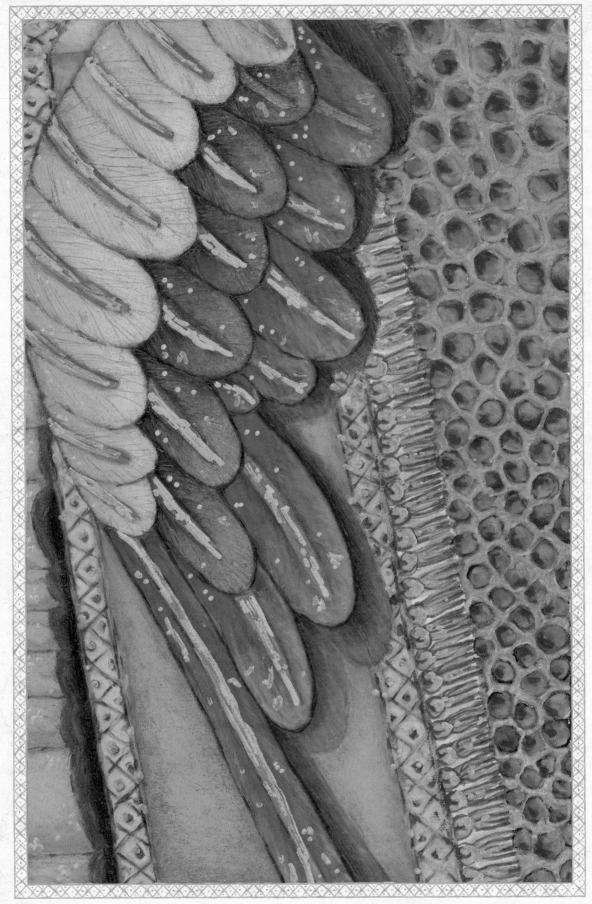

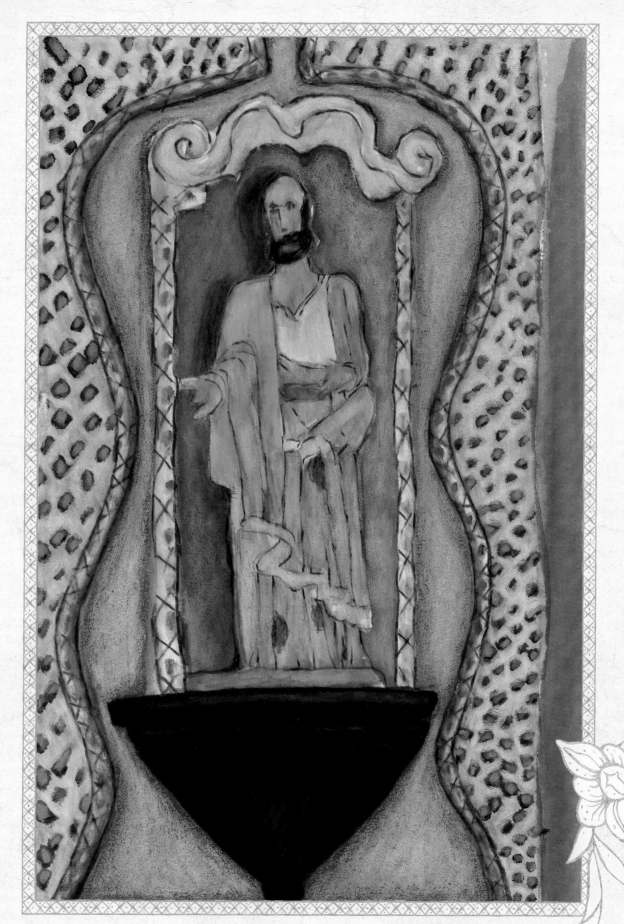

Some of the statues in the church were placed on small shelves, at the base of a hollow in the wall called a niche. Several of the niches are decorated with striking blue dots of paint. Others are surrounded by these blue dots.

Algunas de las estatuas en la iglesia se colocaron en pequeñas repisas, al pie de un hueco en la pared denominado nicho. Varios de los nichos están salpicados o rodeados con brillantes puntos azules.

Patterns and golden flashes embellish walls and angels' wings. A statue of St. Jude Thaddeus.

Diseños y destellos dorados embellecen las paredes y las alas de los ángeles. Una estatua de San Judas Tadeo.

19

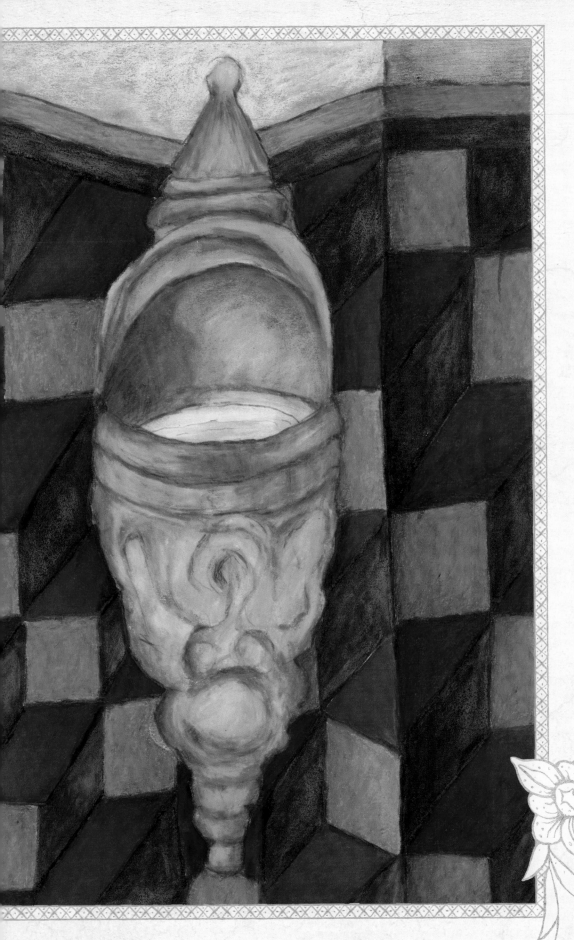

Along the bottom of the inside walls, artists painted a wainscot of deep red, blue, and gold blocks. In some places they painted false doors, windows, and drapes.

A lo largo de la parte baja de las paredes interiores, los artistas pintaron una cenefa con franjas de colores intensos en rojo, azul y dorado. En algunas partes pintaron imitaciones de puertas, ventanas y cortinas.

A font of holy water on the wainscot with a bold geometric pattern.

Una pila de agua bendita en el friso con un diseño geométrico llamativo.

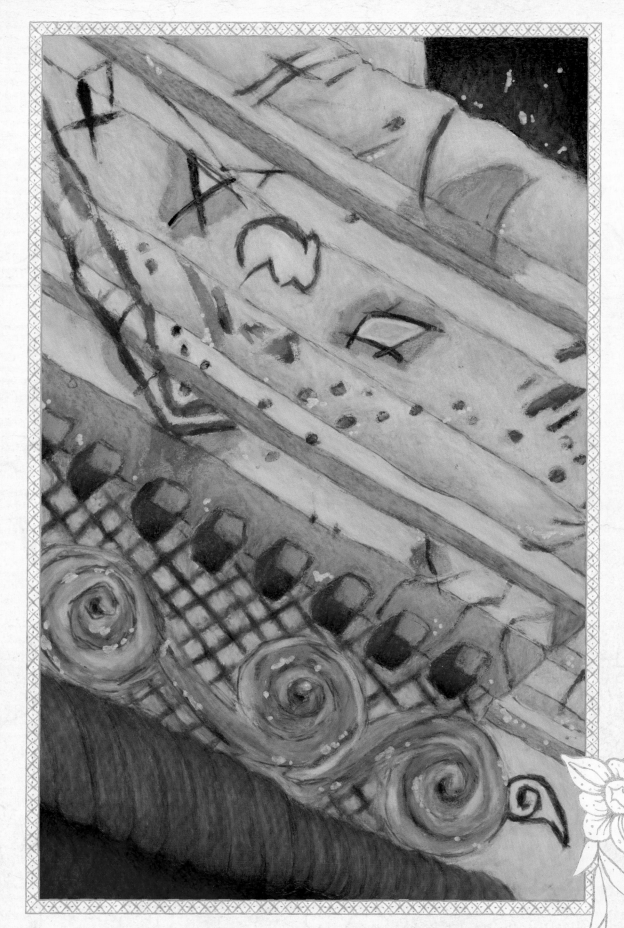

Along the top of the walls and on the ceilings, they painted geometric patterns with lines and, in places, animals such as rabbits, coyotes (or perhaps dogs), and snails.

A lo largo de la parte superior de las paredes se pintaron diseños geométricos con líneas y en algunos lugares animales como conejos, coyotes (o quizás perros) y caracoles.

The cincture, or rope-like belt, of Franciscan friars is represented under the scrolling.

El cinturón de cuerda, de los frailes franciscanos se representa aquí cerca del pie de la imagen.

21

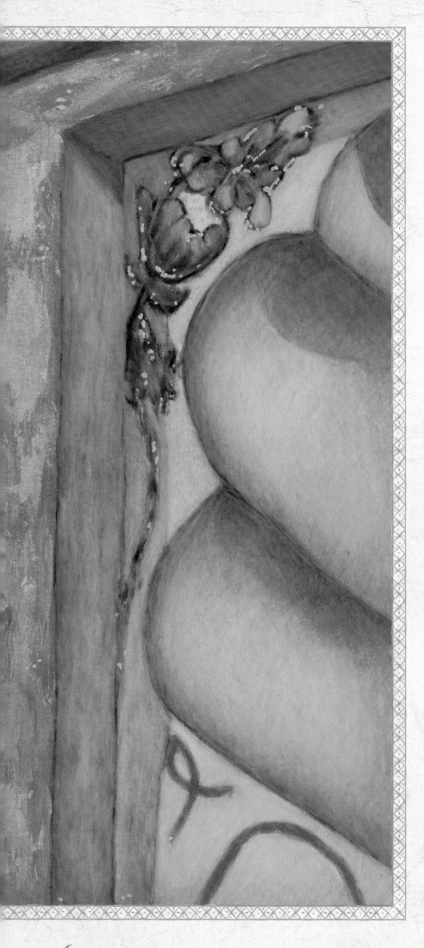

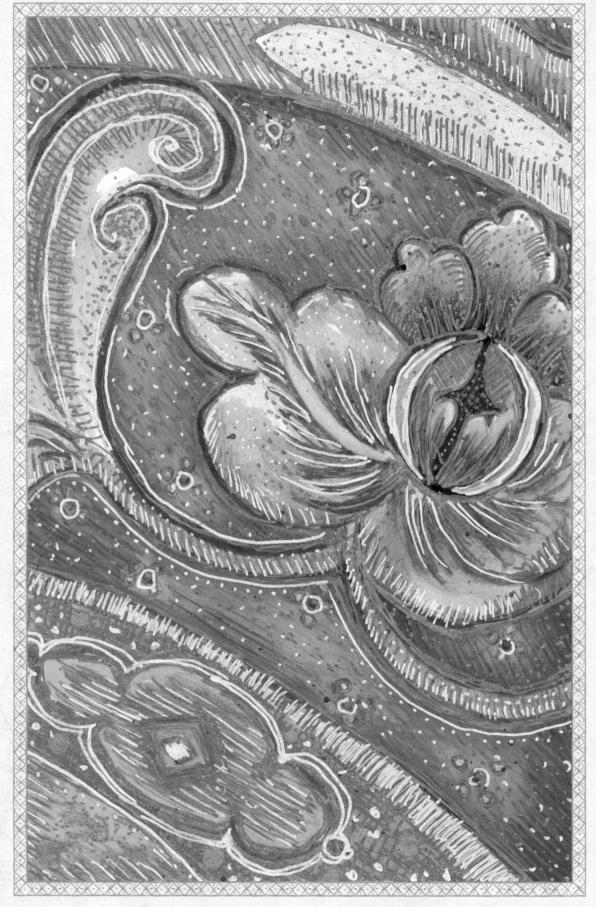

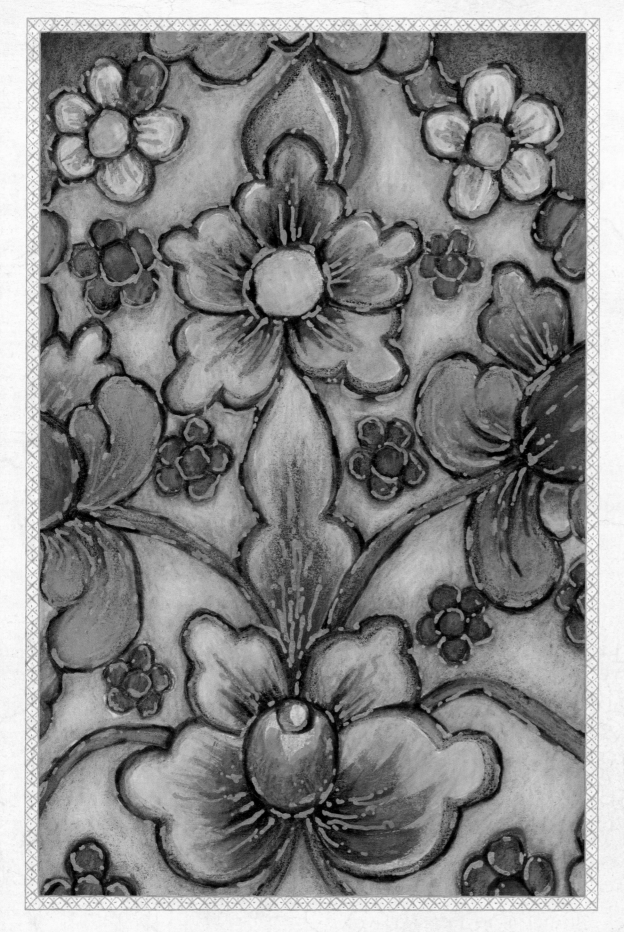

The artists also used flowers, feathers, and shells in their designs. (The shell is a Christian symbol of pilgrimage and, at Mission San Xavier, also represents Saint James the Greater, patron saint of Spain.) The inside of the church glowed with spectacular images and patterns.

Los artistas también usaron flores, plumas y conchas en sus diseños. La concha es un símbolo cristiano de peregrinación y en la Misión de San Xavier también representa a Santiago el Mayor, patrón de España. El interior de la iglesia brillaba con extraordinarias imágenes y diseños.

By 1797, the magnificent church had opened its doors. It was a divine inspiration for its congregants. But after 1827 the Franciscan friars, who had replaced the early Jesuits there, were forced to leave, and the church structure and artwork soon began to suffer under the forces of nature.

En 1797 la magnífica iglesia ya había abierto sus puertas. Sirvió de inspiración divina para los feligreses. Pero después de 1827, los frailes Franciscanos, que habían reemplazado a los primeros Jesuitas, tuvieron que irse y la estructura y las obras de arte de la iglesia empezaron a deteriorarse por las inclemencias del tiempo.

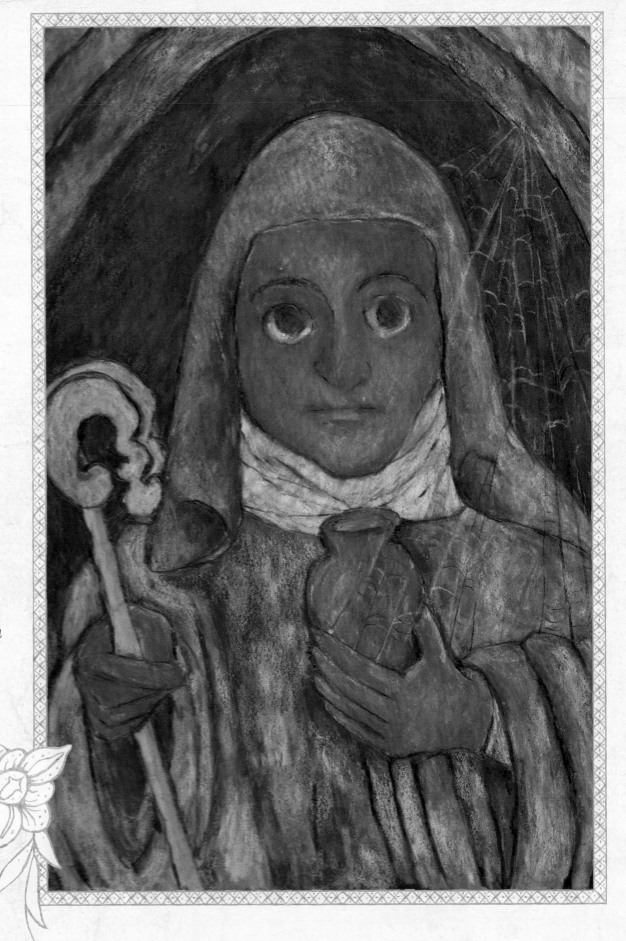

Over time, statues like that of Saint Gertrude turned dark and dingy.

Con el tiempo, algunas estatuas, como la de Santa Gertrudis, se oscurecieron y se volvieron lúgubres.

Two decades later the Jesuits returned, but in 1887, an earthquake seriously damaged the dome ceilings. Workmen repaired much of the damage, but over the years rain from summer monsoons and winter storms seeped into small cracks in the walls and ceilings, damaging the beautiful artwork.

Pasadas dos décadas los Jesuitas regresaron, pero en 1887, un terremoto causó daños considerables a la bóveda del techo. Los obreros trataron de reparar el daño, pero con el correr de los años la lluvia del monzón del verano y las tormentas del invierno penetró por pequeñas grietas en las paredes y techo, dañando las hermosas obras de arte.

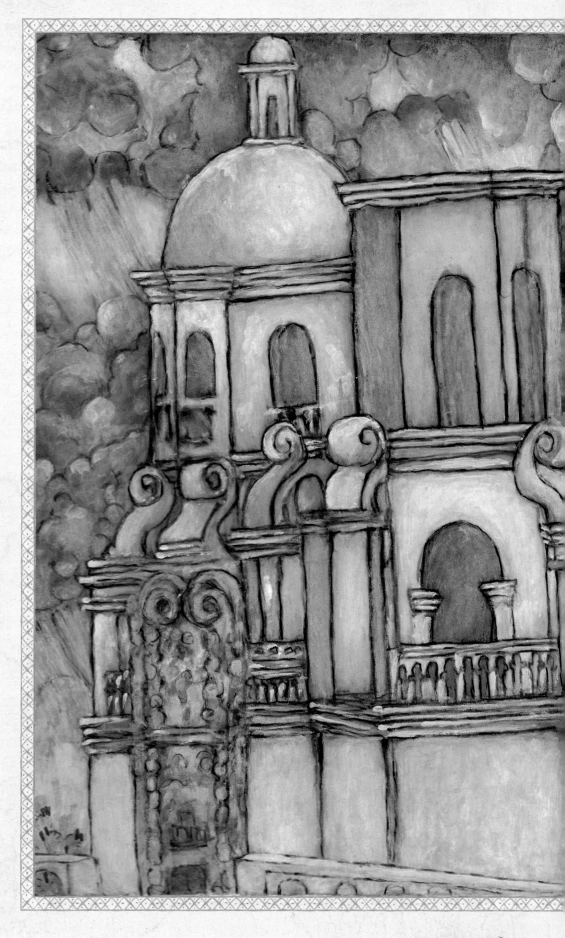

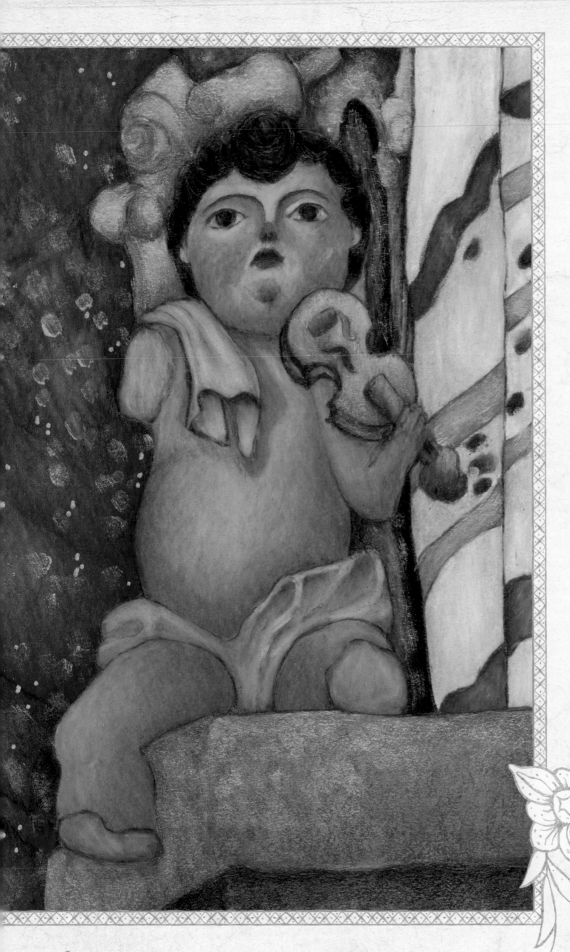

Eventually, the mission needed urgent repair, and people from the community who loved the mission became concerned. They raised money for more repair work, and they did their best to clean up and preserve some of the artwork.

Finalmente, la misión necesitó reparaciones urgentes y la comunidad que amaba la misión se preocupó. Recabaron fondos para más reparaciones y se esforzaron por limpiar y preservar parte de las obras de arte.

An angel on the main altarpiece lost an arm and parts of both legs.

Un ángel en el retablo mayor le falta un brazo y parte de las piernas.

Wasp nests were a big problem because they damaged the painted surfaces throughout the church. Some wasps, like one kind in this church, are also called "mud daubers," because they build their nests out of mud. Dried mud dauber nests can be as hard as cement.

Los panales de avispas fueron un problema serio ya que dañaron la superficie de las pinturas en toda la iglesia. Algunas avispas como una especie de esta iglesia, también se les conoce como "avispas alfareras" porque hacen sus nidos de barro. Los panales secos de las avispas alfareras pueden ser tan duros como el cemento.

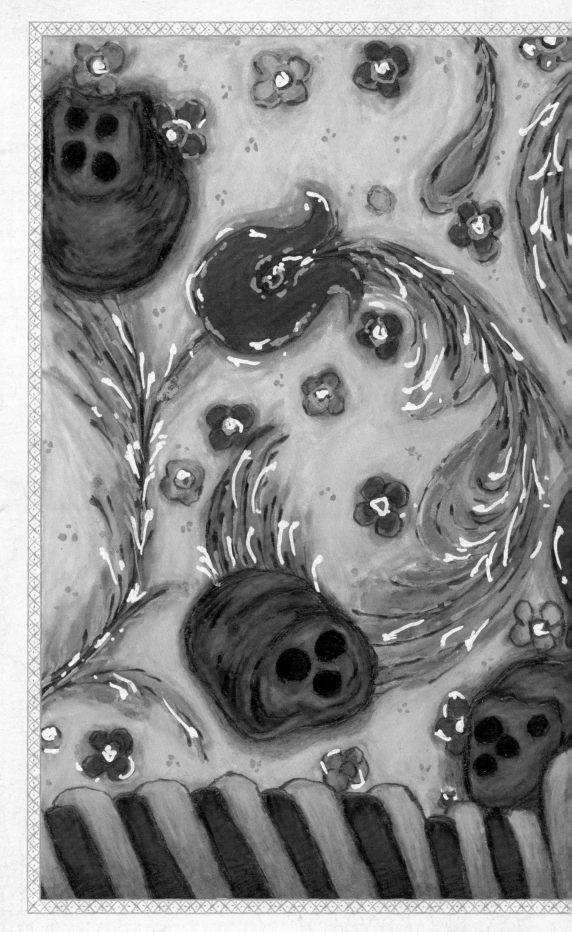

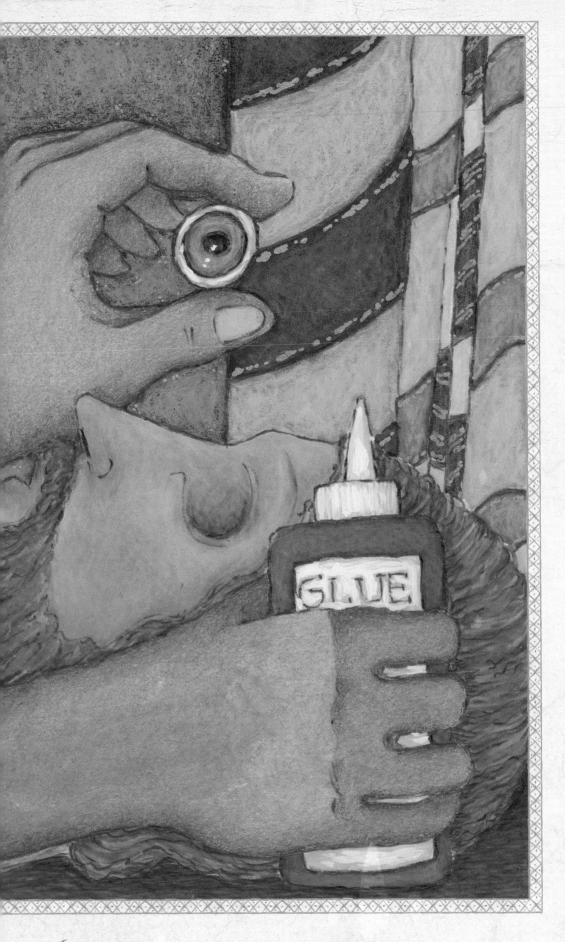

Many of the statues in the church had glass eyes. Some eyeballs had fallen inside the hollow heads, where they rattled when the statues were moved. Some of them were retrieved and replaced into the statue's eye socket. Others had to be replaced with a new eyeball made by the conservator.

Muchas de las estatuas en la iglesia tienen ojos de cristal. Algunos de estos ojos se cayeron dentro de las cabezas huecas donde sonaron cuando se movieron las estatuas. Algunos de ellos se recuperaron y se volvieron a colocar en la cuenca del ojo. Otros se tuvieron que reponer con un ojo de cristal nuevo hecho por el conservador.

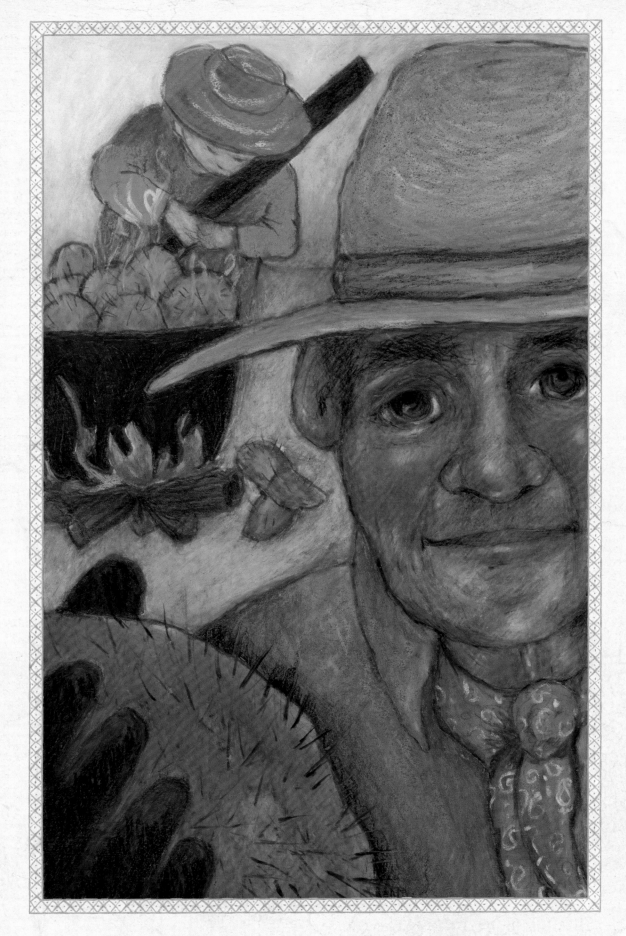

Workmen repaired damaged walls using a lime-and-sand mortar mixed with a water-resistant mucilage made from a centuries-old recipe. The mucilage was made by boiling the stems of nopal cactus and using a mop squeezer to express the juice out of the boiled stems into a wheelbarrow. This sticky green goop was then mixed with the lime and sand.

Los trabajadores repararon las paredes dañadas usando una argamasa de cal y arena mezclada con un mucílago resistente al agua preparada con una receta usada por siglos. El mucílago se preparo al hervir las pencas de nopal y usar un exprimidor de trapeador para soltar el jugo de las pencas hervidas en una carretilla. Después esta viscosidad verde y pegajosa se mezcló con la cal y arena.

Off and on for six years, capable men and women worked to preserve the amazing art and structures of this church. Inside, its richly colored walls, paintings, and statues have recovered much of their old glory. The inspired artwork still touches the hearts and lifts the spirits of local villagers and thousands of visitors every year.

Durante seis años en varios períodos, hombres y mujeres competentes trabajaron para preservar el asombroso arte y la construcción de esta iglesia. Dentro, sus paredes pintadas lujosamente y sus murales y estatuas han recuperado su antiguo esplendor. El mensaje inspirador de las obras de arte sigue llegando al corazón y alegrando a los lugareños y miles de visitantes que llegan cada año.

The main altarpiece. / *El retablo mayor.*

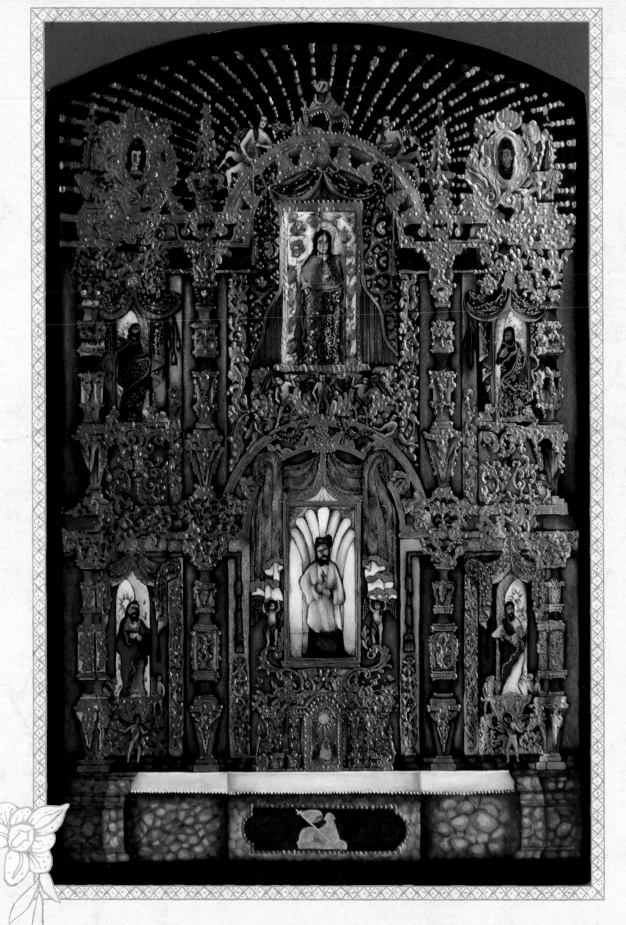

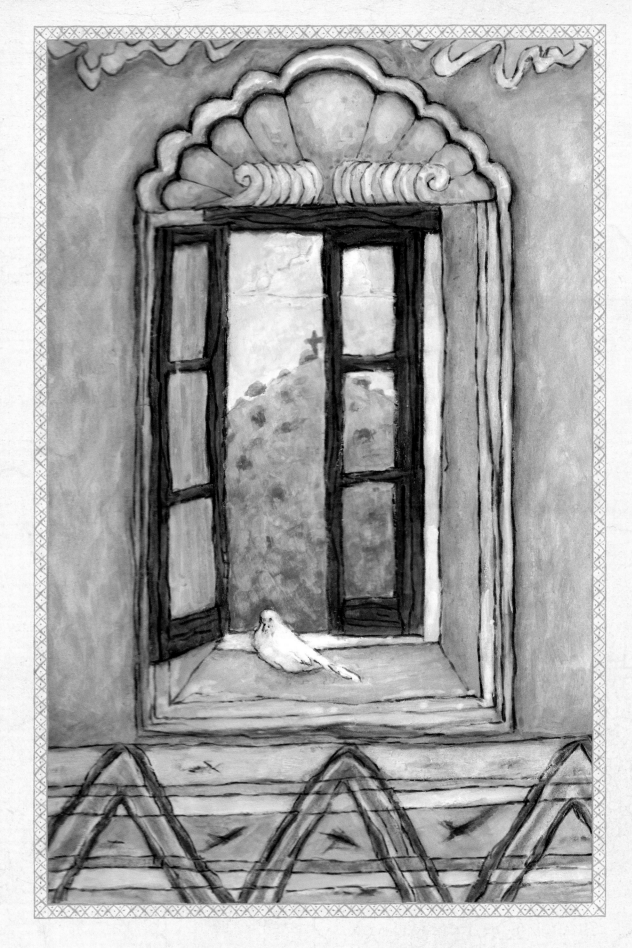

On the outside, the clean white walls of the mission glow under the sun. A solace to travelers and residents, it is a symbol of peace and of the Holy Spirit, like a white dove in the desert. Come visit the mission and see if you can find all the saints and angels, painted animals, colorful flower designs, and other hidden treasures on its walls. Look about and you will know the glory of the Mission San Xavier del Bac.

Por fuera, las blancas paredes de la misión brillan bajo el sol. Un consuelo para los viajeros y residentes, es un símbolo de paz y del Espíritu Santo, como una paloma blanca en el desierto. Ven y visita la misión y ve si puedes encontrar todos los santos y ángeles, animales, coloridos diseños florales y otros tesoros escondidos en sus paredes. Mira a tu alrededor y descubrirás el esplendor de la Misión de San Xavier del Bac.

Between 1992 and 1997, a team of international conservators joined local artists and technicians in a major effort to conserve the art and design elements in the Mission San Xavier del Bac. The international team was assembled and coordinated by Paul Schwartzbaum, Head of Conservation for the Solomon R. Guggenheim Museum in New York and the Peggy Guggenheim Museum in Venice, Italy. Members of the international team included: Carlo Giantomassi and Donatella Zari (on-site supervisors), Mario Pulieri, Paola Zari, Vincenzo Centanni, Gabrielle Magni, and Silvia Reggiannini from Italy; Ridvan Isler from Turkey; Matilde Rubio from Spain; and Svitlana Hluvko from England. Apprentice conservators came from the local Tohono O'odham community, including Tim Lewis, Gabriel Wilson, Mark Lopez, Anthony Encinas, Michael Campos, and Donald Preston. Records and technical analyses were provided by Lorenzo Lazzarini and Ippolito Massari of Italy, and Sally Ritts, Helga Teiwes, and Edna San Miguel of the United States. Svitlana Hluvko and Edna San Miguel documented the various treatment processes with drawings, photos, and day-to-day detailed logs. Many others were involved in the campaign—too many to be listed here—but the contributions of all the participants were important in accomplishing the conservation work.

During the conservation program, many of the original materials and techniques used by the builders and artists of the Mission San Xavier del Bac were analyzed and documented. The following text describes several of these original materials and techniques, as well as a few of the challenges encountered and solutions found.

De 1992 a 1997, un equipo de conservadores internacionales se unió a artistas y técnicos de la región en un importante trabajo de restauración del arte y diseños en la Misión de San Xavier del Bac. El equipo internacional fue reunido y coordinado por Paul Schwartzbaum, Director de Conservación del Museo Solomon R. Guggenheim de Nueva York y el Museo Peggy Guggenheim de Venecia, Italia. Entre los miembros del equipo internacional se encontraban: Carlo Giantomassi y Donatella Zari (supervisores de obra), Mario Pulieri, Paola Zari, Vincenzo Centanni, Gabrielle Magni y Silvia Reggiannini de Italia; Ridvan Isler de Turquía; Matilde Rubio de España y Svitlana Hluvko de Inglaterra. Los aprendices de conservadores fueron de nuestra comunidad Tohono O'odham, entre ellos Tim Lewis, Gabriel Wilson, Mark López, Anthony Encinas, Michael Campos y Donald Preston. La documentación y análisis técnicos fueron realizados por Lorenzo Lazzarini e Ippolito Massari de Italia, Sally Ritts, Helga Teiwes, y Edna San Miguel de Estados Unidos. Svitlana Hluvko y Edna San Miguel documentaron los diferentes procesos de restauración con dibujos, fotografías y registros diarios detallados. Muchas otras personas participaron en este programa, demasiados para nombrarlos a todos, pero las aportaciones de todos los participantes fueron relevantes para lograr el trabajo de conservación.

Durante el programa de conservación, varios de los materiales y técnicas originales usados por los constructores y artistas de la Misión de San Xavier del Bac se analizaron y documentaron. El texto siguiente describe algunos de estos materiales y técnicas originales, así como algunos de los problemas que se presentaron y sus soluciones.

The Mission San Xavier del Bac was constructed more than two hundred years ago with locally made adobe brick. Foundations for the mission were built with a porous volcanic rock found close by. The two large entry doors under the portal at the front of the church were made of mesquite. Other doors, window frames, and some architectural forms were also constructed of wood (pine and mesquite would have been locally available, but the material used for many of these wooden elements has not yet been analyzed). Local minerals and plant materials also show up in the mission's decor. Pigment analyses from its painted surfaces suggest that some of the black paint was made with pulverized charcoal. Some red paints were probably prepared with hematite (iron oxide). Some ochres *may* have been derived locally, but most colors, particularly the bright ones, had to be brought in from Mexico (New Spain at the time).

The flat surfaces, domes, and arches in the interior of the church are heavily decorated with paintings that narrate stories from the Bible and from church history, as well as figurative and floral images and abstract patterns. Many, if not most, of the narrative paintings were not drawn first, but painted directly on the walls or ceilings. For the frames painted around the murals and possibly some of the floral decorations, the original artists used a technique called

Before the application of the original paintings, the selected surface was prepared in a three-step process to produce a smooth, slick area appropriate for the painting of intricate designs. For the frescoes, the wall surfaces were prepared first with a layer of coarse plaster made of lime carbonate and sand called "arriccio." A very fine plaster called "intonaco" composed of a lime carbonate and more finely sifted sand, as well as a small quantity of gypsum anhydrite, provided a second coat. The third coat, called "intonacino" was made of gypsum mixed with a small quantity of anhydrite and traces of quartz. This final coat was applied with a brush to the surface before the designs or murals were painted on it.

The team of conservators found a range of problems in this magnificent but periodically neglected church. For instance, wooden statues were often infested by insects and, once infested, parts of a statue could easily break off. The right foot of Saint Francis of Assisi had broken in half as the result of an insect infestation.

The original coloring of the flesh of the angels and female saints in the upper registers of the west transept had been pinkish, but at some point in the history

The thoughts and decisions by all conservators in the treatment of restoration were to intervene as little as possible. The San Xavier Mission was just in need of a very sophisticated cleaning and stabilization.

~ PAUL SCHWARTZBAUM

"pouncing." Pouncing is a type of stencil technique used to transfer drawings or patterns before the elements are painted in. This technique is accomplished by pricking holes through the lines of a preliminary drawing (or a copy of it) on paper. The drawing is positioned on the wall and a sack filled with powdered charcoal is pressed onto on the surface of the drawing, thus pushing the charcoal through the holes onto the wall or ceiling, and leaving a replica of the drawn image on that surface. In Italy pouncing is called "spolvero," a technique used since the 1400s.

of the church, the skin was painted with a darker flesh tone, presumably so that the O'odham congregants could identify with the images. In the recent conservation work, workers did not remove the brown overpainting in deference to the earlier decision and its part in the mission's history. In some places, thick layers of paint and varnish had peeled away from the original sculptures and later plaster coatings. Conservators reattached these lifted or detached layers with a mixture of Rhoplex™, water, and alcohol. Areas of color lost in the faces, hands, and feet were reintegrated with the use of Winsor Newton

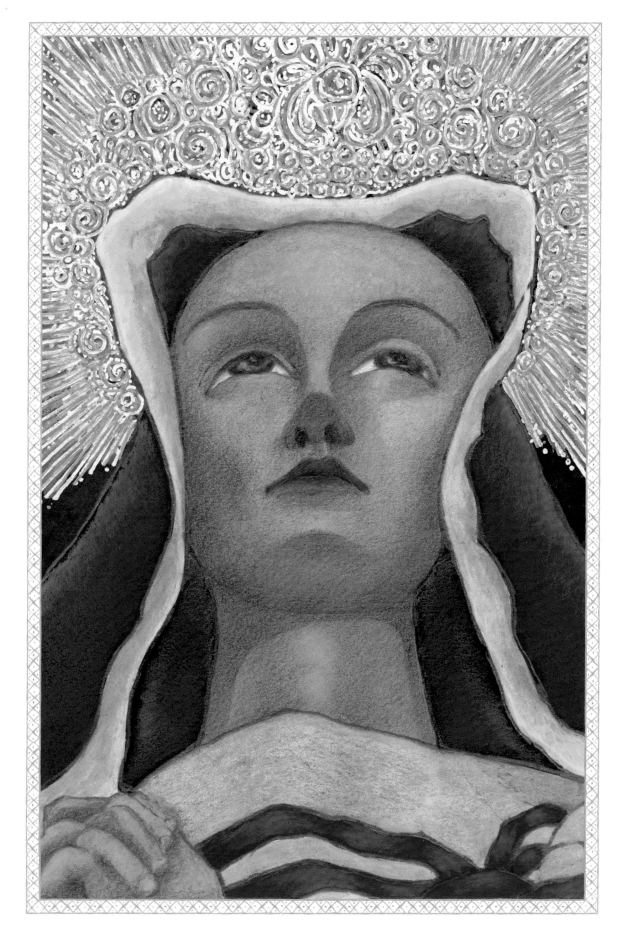

VIRGIN MARY AS THE SORROWFUL MOTHER

This depiction of Mary as the Sorrowful Mother is one of three statues of the Virgin Mary at the mission, and one of a dozen or more depictions of her here. This full wooden figure has a painted face and glass eyeballs and is clothed in a rich blue or deep violet garment that is changed periodically. She wears a veil and a crown. Faces of angels are on the wall behind and above her head. This statue, which was present in the church in 1768, stands in the center of the altarpiece in the east transept.

LA MADRE DOLOROSA

La representación de María como la Madre Dolorosa es una de las tres estatuas de la Virgen María en la misión y una de poco más de una docena de pinturas o esculturas de ella allí. Esta imagen de cuerpo entero de madera, tiene cara pintada y ojos de cristal y lleva un vestido azul vivo o violeta intenso que se le cambia periódicamente. También lleva velo y corona. En la pared de fondo y sobre su cabeza están caras de ángeles. Esta estatua, que ya estaba en la iglesia en 1768, ocupa el centro del retablo en el transepto este.

MARY AS THE IMMACULATE CONCEPTION

There are two representations of Mary as the Immaculate Conception at the mission. In this one, she is also called the "Most Pure Woman." The appellation of Mary as the Immaculate Conception reflects the Catholic belief that Mary was free from "original sin" from birth as the future mother of Christ. The clothing on this wooden statue was made from cloth made rigid with gesso and then painted. The statue is thought to have been brought from the Tumacácori mission by O'odham villagers when Apaches raided that mission in 1848. It stands in a low niche of the north wall in the east transept.

LA INMACULADA CONCEPCIÓN

En la misión hay dos representaciones de María como la Inmaculada Concepción. También se le conoce como la Purísima Concepción. El nombre de La Inmaculada Concepción de María refleja la creencia católica de que María como futura madre de Cristo nació libre del "pecado original". El vestuario de esta imagen de madera se hizo de tela endurecida con gesso y después pintada. Se piensa que los pobladores O'odham llevaron esta estatua desde la Misión de Tumacácori cuando ésta fue atacada por los Apaches en 1848. Ocupa un nicho inferior en la pared norte del transepto este.

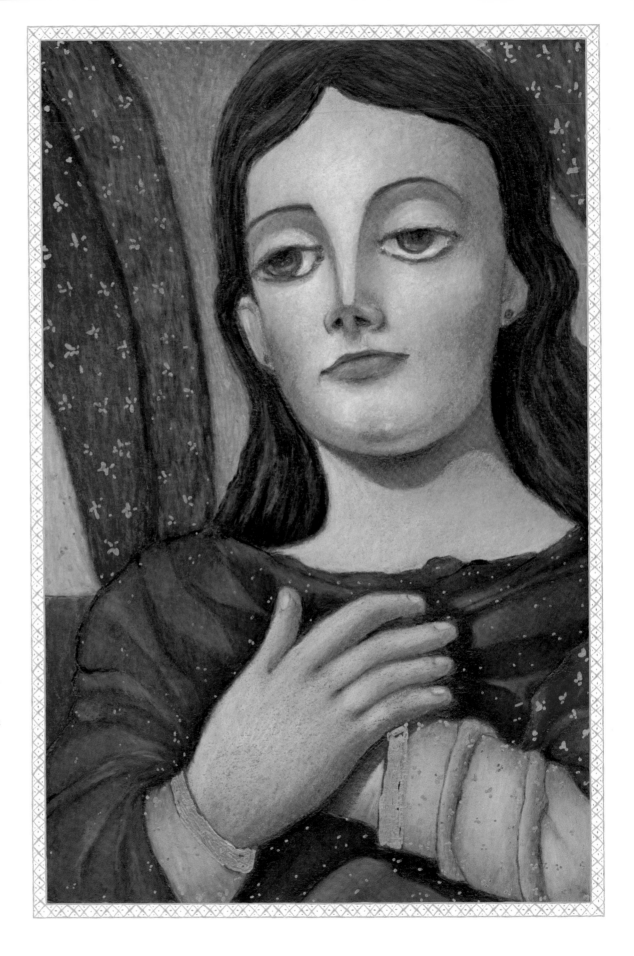

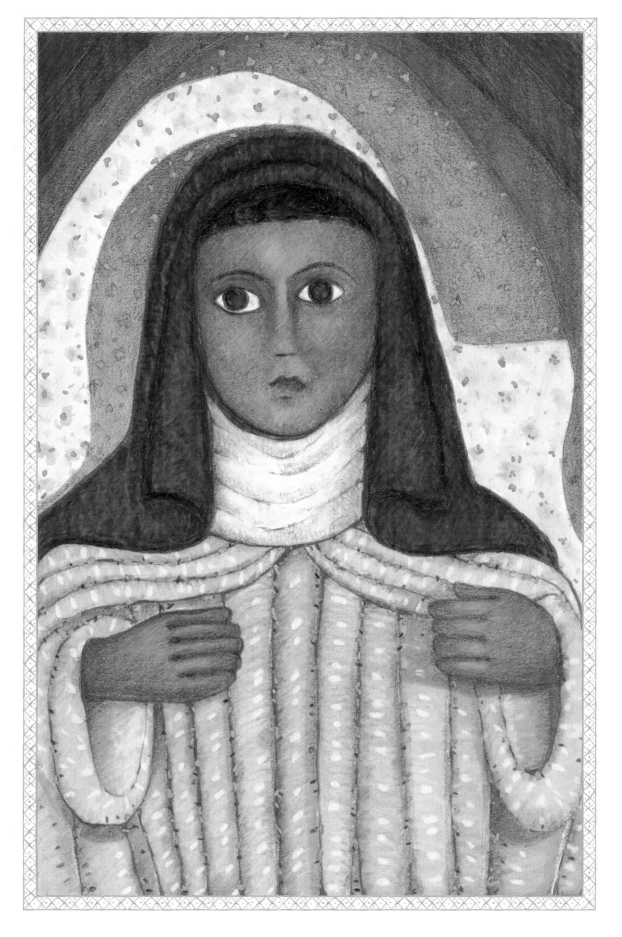

SAINT COLETTE

Born Nicolette Boilet in France, Saint Colette was a Franciscan nun in the Order of the Poor Clares in the early fifteenth century. She worked to reform the order, establishing seventeen convents, and was canonized in 1807. She is a patron of the Poor Clares, carpenters, and others. A sculpture of a woman from the waist up, recessed into the north wall of the west transept at the top right, is thought to be Saint Colette. Her skin, like that of some other nuns in medallions, was painted brownish at some point in the history of the church.

SANTA COLETA

Nacida en Francia como Nicoleta Boilet, Santa Coleta fue una monja Franciscana de la Orden de las Clarisas Pobres a principios del siglo XV. Reformó la orden y fundó 17 nuevos conventos; fue canonizada en 1807. Es patrona de las Clarisas Pobres y los carpinteros, entre otros. Una escultura de mujer de medio cuerpo en la pared norte del transepto oeste y en la parte superior derecha, se piensa que es Santa Coleta. En algún punto de la historia de la iglesia, su piel al igual que la de otras monjas en los medallones, fue pintada de un color más oscuro.

BONAVENTURE

This bishop and minister-general of the Franciscan Order was born Giovanni di Fidanza in Italy in 1221. He earned a doctor of theology degree at the University of Paris, where he also taught. He wrote the *Life of Saint Francis* and was influential in the development of the church. He is a patron saint of Franciscans, theologians, workers, children, and others. This wooden sculpture, in a niche centered in the west altarpiece of the west transept, was among those carried from the Tumacácori mission to San Xavier mission in 1848 due to Apache raids at Tumacácori.

SAN BUENAVENTURA

Este obispo y ministro general de la Orden Franciscana nació en Italia en 1221 como Giovanni di Fidanza. Obtuvo el grado de doctor en teología en la Universidad de Paris, donde también impartió clases. Escribió La Vida de San Francisco y fue influyente en el desarrollo de la iglesia. Es el santo patrono de los Franciscanos, teólogos, trabajadores y niños, entre otros. Esta escultura de madera en el nicho central del retablo oriental del transepto oeste, fue una de las llevadas desde la Misión de Tumacácori a la Misión de San Xavier por los ataques de los Apaches a Tumacácori en 1848.

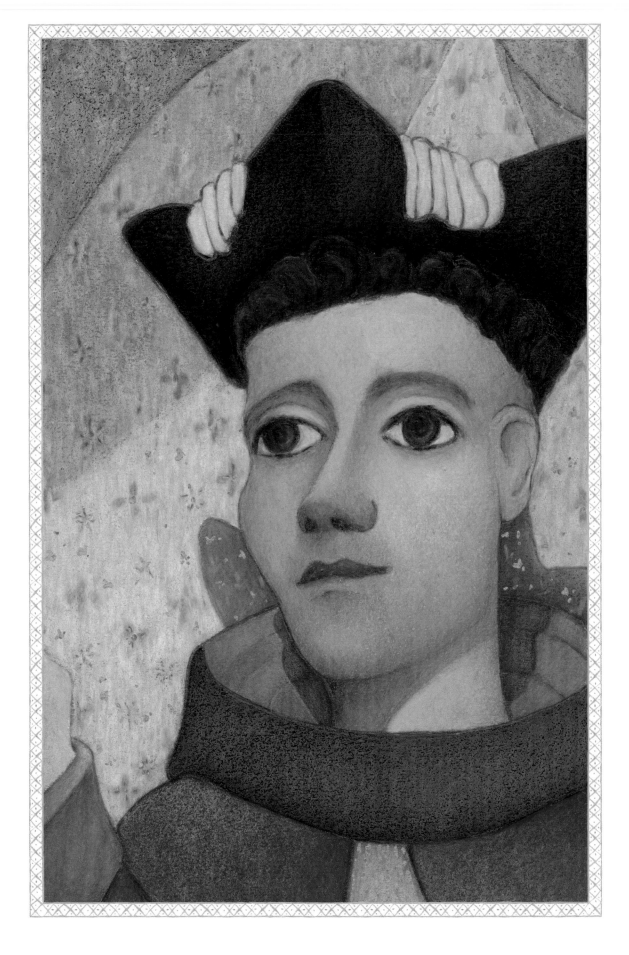

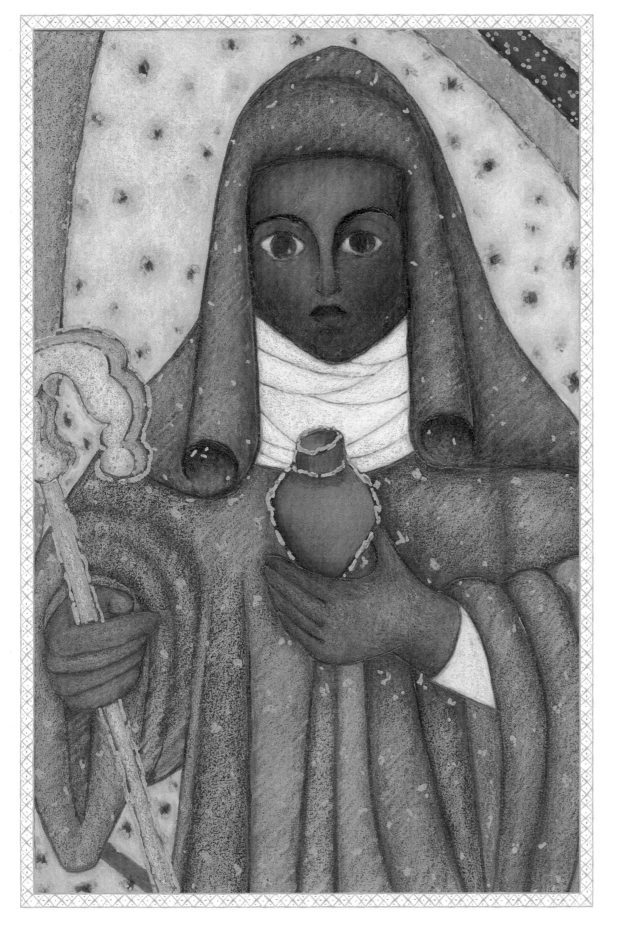

SAINT GERTRUDE THE GREAT

Dubbed Gertrude the Great, this French Benedictine nun lived in the latter half of the thirteenth century. Her family background is unknown, but she came to live in a monastery at the age of five. As an adult, she had many revelations and visions, which she wrote about extensively, and she is recognized as an important mystic of the medieval period. She holds a flaming heart in her left hand. A brick and plaster figure of Saint Gertrude from the waist up is on the top left side of the west wall of the west transept.

SANTA GERTRUDIS LA GRANDE

Apodada Gertrudis la Grande, esta monja benedictina francesa vivió en la segunda mitad del siglo XIII. Se desconoce la historia de su familia, pero fue a vivir en un monasterio a la edad de cinco años. Siendo adulta, tuvo muchas revelaciones y visiones, sobre las que escribió bastante y se reconoce como una importante mística del período medieval. Sostiene un corazón en llamas en su mano izquierda. Una imagen de Santa Gertrudis de medio cuerpo, en ladrillo y yeso, se encuentra en la parte izquierda superior de la pared occidental del transepto oeste.

SAINT THERESA OF ÁVILA

A Spanish Carmelite nun and patron of scholars, Saint Theresa lived in the sixteenth century. She was a mystic and an influential writer who received a doctoral degree and was also a doctor of the church. A reformer, she founded several convents of the Order of Our Lady of Mount Carmel (also known as the "barefoot branch" of the Carmelites). A half-figure in brick and plaster of Saint Theresa can be seen above the altar, at the center top of the west wall of the west transept.

SANTA TERESA DE ÁVILA

Una monja española de la Orden de las Carmelitas y patrona de los escolásticos, Santa Teresa vivió en el siglo XVI. Fue mística e influyente escritora recibiendo su grado de doctor, también fue doctora de la iglesia. Una reformadora, fundó varios conventos de la Orden de Nuestra Señora del Monte Carmelo (rama de las Carmelitas Descalzas). Una figura de medio cuerpo de ladrillo y yeso de Santa Teresa se observa arriba del altar, en el centro superior de la pared occidental del transepto oeste.

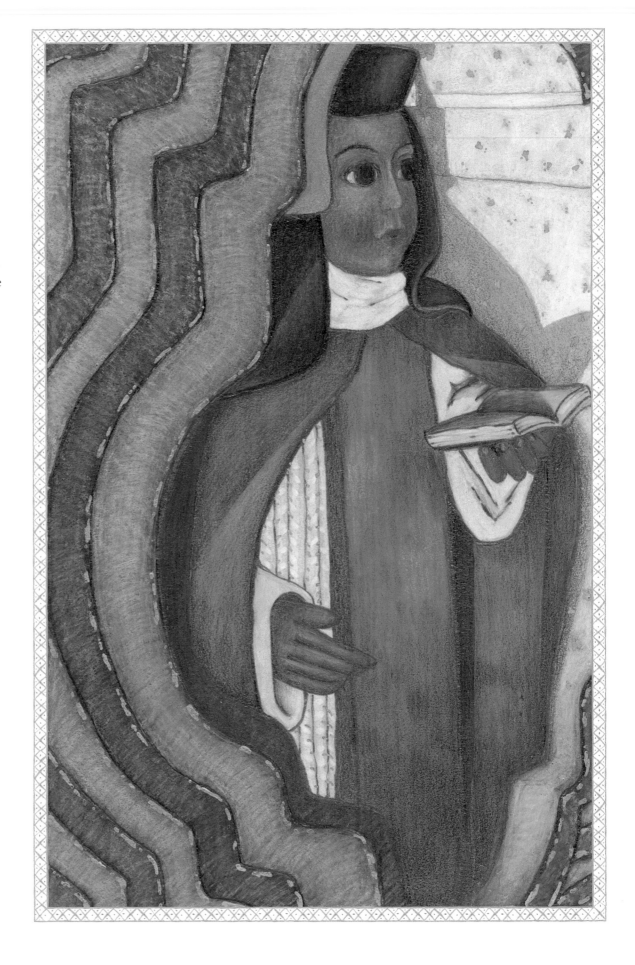

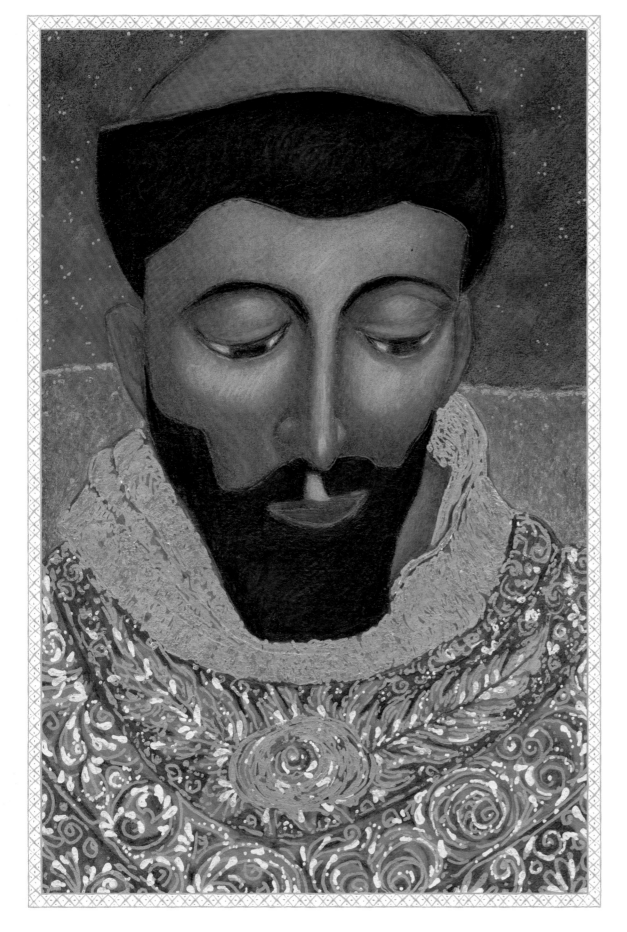

SAINT FRANCIS OF ASSISI

Francis di Bernadone founded the Franciscan order in 1209. Although he was born to a family of wealthy Italian merchants, he promoted the virtues of poverty, chastity, simplicity, and obedience. He is the patron saint of environmentalists and social workers. He was a contemporary with and worked with Saint Clare to establish the Poor Clares. He was canonized in 1228, just two years after his death. A wooden sculpture of Saint Francis with gold leaf on his clothing stands in a niche in the middle tier in the center of the west transept. This gilt cloth is an artist's preference, not in keeping with the simple life of Saint Francis.

SAN FRANCISCO DE ASÍS

Francisco di Bernardone fundó la Orden Franciscana en 1209. Aunque nació en el seno de una familia de ricos comerciantes italianos, prometió las virtudes de pobreza, castidad, sencillez y obediencia. Es el santo patrón de los ambientalistas y los trabajadores sociales. Fue contemporáneo de Santa Clara y juntos trabajaron para establecer la Orden de las Clarisas Pobres. Fue canonizado en 1228, justo dos años después de su muerte. Una escultura de madera de San Francisco, con laminado de oro en sus vestiduras, ocupa un nicho en el nivel medio al centro del transepto oeste. La vestidura dorada es una preferencia del artista, no una representación de la vida sencilla de San Francisco.

MARY AS THE IMMACULATE CONCEPTION

This is the second representation of Mary, the mother of Jesus, as the Immaculate Conception. Flowers decorate her garment, which is generously trimmed in gold. Behind her, the curved wall of the niche is decorated with a bold floral design. Under her, a crescent moon and angels. The full figure, a painted wooden sculpture, is in the sanctuary in the central altarpiece, just beneath an image of "God the Father."

LA INMACULADA CONCEPCIÓN

Esta es la segunda representación de María, la madre de Jesús, como la Inmaculada Concepción. Flores decoran su vestido, el que está generosamente adornado con oro. Al fondo, la pared curva del nicho está decorada con un llamativo diseño floral. Tiene una media luna y ángeles bajo sus pies. La escultura de cuerpo entero, de madera pintada, está en el santuario en el retablo central, justo debajo de una imagen de "Dios Padre".

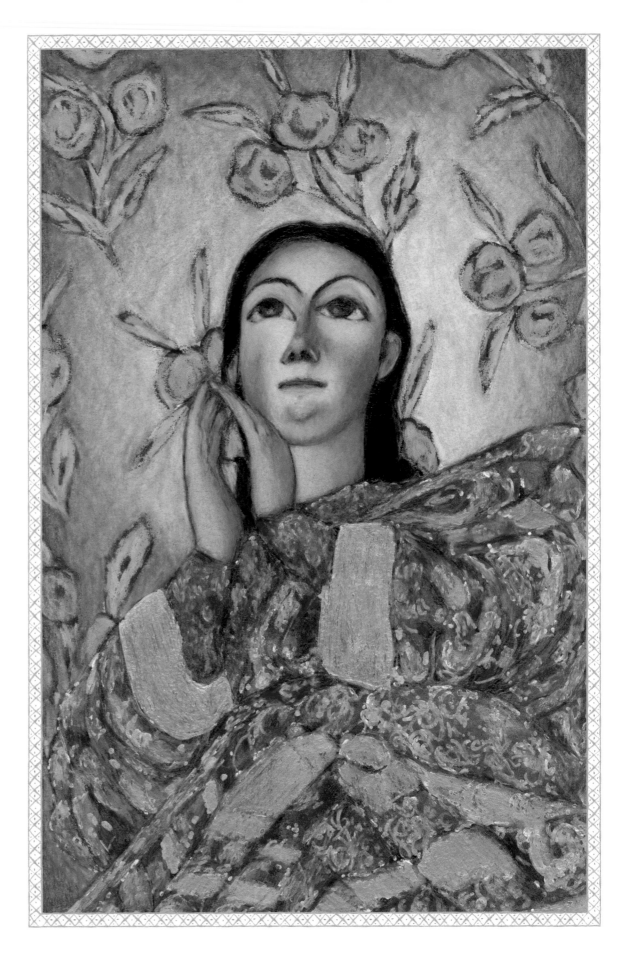

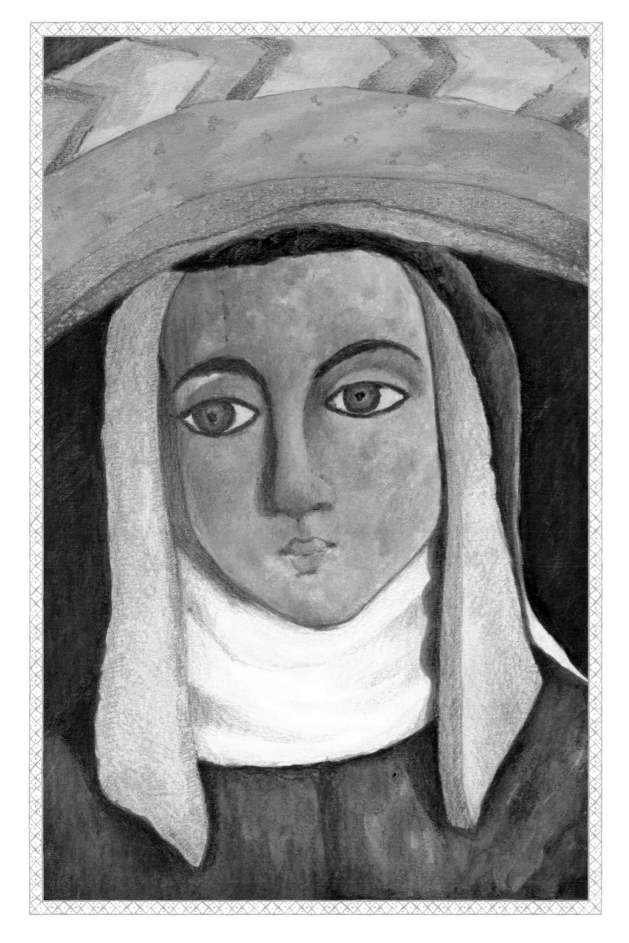

SAINT RITA

This figure is thought to be Saint Rita (once identified as Saint Scholastica), who lived in the late fourteenth and early fifteenth centuries in Italy. She joined an Augustinian convent in 1413 as a 32-year-old widow, an unusual situation. She is known as a patron of "desperate cases," especially problems in marriage. A plaster and brick sculpture of Saint Rita from the waist up can be seen high on the left side of the north wall in the west transept.

SANTA RITA

Se piensa que está figura es Santa Rita (identificada una vez como Santa Escolástica) quien vivió a finales del siglo XIV y principios del siglo XV en Italia. Entró a un convento agustino en 1413 siendo una viuda de 32 años, una situación poco común. Se conoce como patrona de las "causas desesperadas" en especial problemas del matrimonio. Una escultura de medio cuerpo de Santa Rita en ladrillo y yeso se puede observar a lo alto en la parte izquierda de la pared norte en el transepto oeste.

Map of Mission Statuary /
Mapa del Estatuario de la Misión

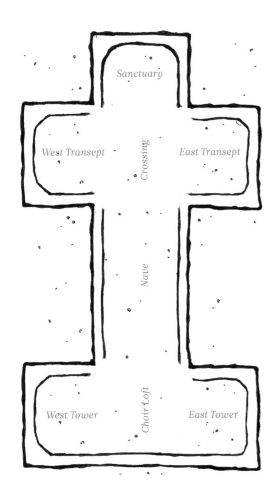

Sanctuary

West Transept · Crossing · East Transept

Nave

Choir Loft

West Tower · East Tower

The towers on either side of the choir loft are not represented in the statuary map.

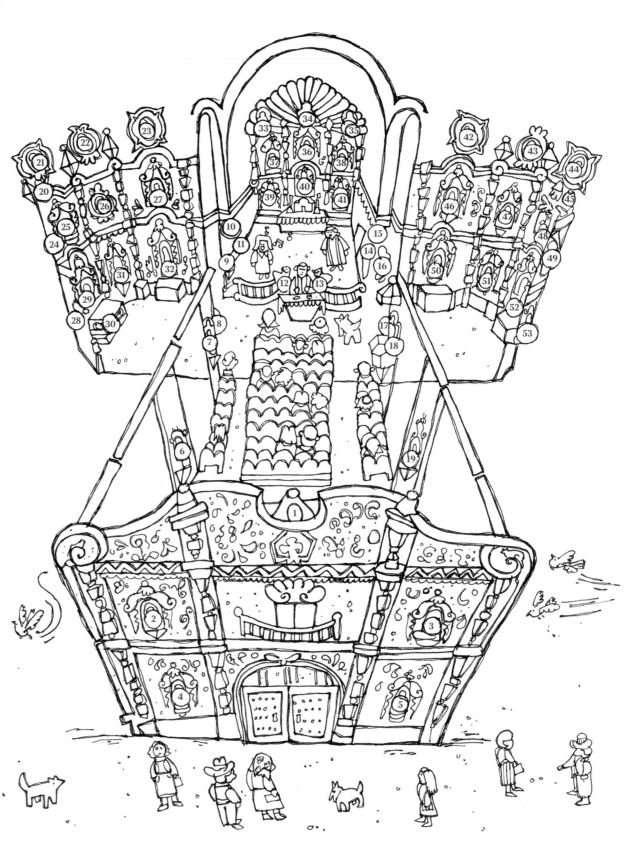

This diagram is a "map" of the church of the Mission San Xavier del Bac, looking down from above the facade and into the interior. The numbers on the accompanying list of statues correspond with the numbers within the circles in the diagram. The map includes most of the significant statues in the church (including those not illustrated in this book).

The diagram, by Edna San Miguel, is based on a similar diagram in *The Sculpted Saints of a Borderland Mission* by Richard Eighme Ahlborn published by the Southwest Mission Research Center, Tucson, Arizona (1974), and is reproduced with permission. The identifications are from the authoritative tome on the art of the Mission San Xavier del Bac, *A Gift of Angels*, by Bernard L. Fontana, published by the University of Arizona Press, Tucson (2010).

Este diagrama es un "mapa" de la iglesia de la Misión de San Xavier del Bac, mirando hacia abajo desde la fachada y hacia el interior. Los números en la lista de estatuas acompañante corresponden a los números de los círculos en el diagrama. El mapa incluye casi todas las estatuas importantes en la iglesia (incluso las que no se ilustran en este libro).

El diagrama, elaborado por Edna San Miguel, se basa en un esquema similar en el libro The Sculpted Saints of a Borderland Mission *de Richard Eighme Ahlborn publicado por el Southwest Mission Research Center, Tucson, Arizona (1974) y cuenta con permiso para su reproducción. Las identificaciones provienen del bien documentado tomo en el arte de la Misión de San Xavier del Bac,* A Gift of Angels, *de Bernard L. Fontana, publicado por la University of Arizona Press, Tucson (2010).*

1	St. Francis Xavier / *San Francisco Xavier*		28	St. Ildephonsus* / *San Ildefonso**
2	St. Barbara* / *Santa Bárbara**		29	Man of Sorrows / *El Varón de Dolores*
3	St. Cecilia / *Santa Cecilia*		30	St. Francis Xavier, in repose / *San Francisco Xavier, acostado*
4	St. Catherine of Alexandria* / *Santa Catalina de Alejandría**		31	St. Bonaventure / *San Buenaventura*
5	St. Lucy of Syracuse / *Santa Lucía*		32	St. Joseph / *San José*
6	St. Matthew* / *San Mateo**		33	St. Lawrence the Martyr / *San Lorenzo*
7	St. John the Evangelist* or St. Thomas* / *San Juan Apóstol* o Santo Tomás**		34	God the Father / *Dios Padre*
8	St. Philip the Apostle* [south wall, west transept] / *San Felipe Apóstol* [pared sur, transepto oeste]*		35	St. Stephen / *San Esteban*
9	St. Bartholomew* / *San Bartolomé**		36	Mary, The Immaculate Conception / *La Inmaculada Concepción*
10	Angel / *Ángel*		37	St. Peter / *San Pedro*
11	Santiago (James the Greater) / *Santiago (Santiago el Mayor)*		38	St. Paul / *San Pablo*
12	Lion / *León*		39	St. Simon the Zealot* / *San Simón el Zelote**
13	Lion / *León*		40	St. Francis Xavier / *San Francisco Xavier*
14	St. Matthias / *San Matías Apóstol*		41	St. Andrew / *San Andrés*
15	Angel / *Ángel*		42	St. Agnes of Bohemia* / *Santa Inés de Bohemia**
16	St. Ignatius of Loyola / *San Ignacio de Loyola*		43	St. Elizabeth of Portugal / *Santa Isabel de Portugal*
17	Judas Thaddeus [south wall, east transept] / *San Judas Tadeo [pared sur, transepto este]*		44	St. Clare of Assisi / *Santa Clara de Asís*
18	Pulpit / *Púlpito*		45	St. Elizabeth of Hungary / *Santa Isabel de Hungría*
19	St. James the Less / *Santiago el Menor*		46	St. Benedict of San Philadelphio / *San Benito de Palermo*
20	St. Gertrude the Great / *Santa Gertrudis la Grande*		47	Blessed Bernard of Feltre / *Beato Bernardino de Feltre*
21	St. Theresa of Ávila / *Santa Teresa de Ávila*		48	The Crucifixion / *La Crucifixión*
22	St. Rita of Cascia* / *Santa Rita de Casia**		49	St. Fidelis of Sigmaringen / *San Fidel de Sigmaringa*
23	St. Colette* / *Santa Coleta**		50	Mary, The Immaculate Conception / *La Inmaculada Concepción*
24	St. Peter Regalatus / *San Pedro Regalado*		51	St. James of Alcalá / *Santiago de Alcalá*
25	St. Francis of Assisi / *San Francisco de Asís*		52	Mary, Our Lady of Sorrows / *La Madre Dolorosa*
26	St. Peter of Alcántara / *San Pedro de Alcántara*		53	St. Anthony of Padua / *San Antonio de Padua*
27	St. Dominic / *Santo Domingo de Guzmán*			

An asterix indicates an uncertain identification.

Glossary / *Glosario*

adobe ∽ a mix of sand, clay, water, and straw or similar fibrous material, hardened into bricks for construction.

architectural relief ∽ a sculptured artwork or design that is raised from a flat surface like a wall or column. Three kinds of relief include bas-relief, which projects only slightly from the surface; high relief, in which the raised elements show more than half a full three-dimensional representation; and sunken relief, in which the image or design is depressed into the even surface (as if an object or design was pressed into a soft surface).

arriccio ∽ coarse plaster made of lime carbonate and sand, used for a base layer under a finer plaster applied for fresco.

burnish ∽ to make shiny by rubbing; to use a tool to compact or smooth.

conservator ∽ in art, a person skilled in and/or working to maintain or restore art, artifacts, or other valuable items.

cornice ∽ a horizontal molded projection from a vertical surface; a ledge on the upper edge of a wall.

dome ∽ an architectural structure shaped like the upper half of a hollow ball, usually used as a roof or part of a roof.

driver ∽ in reference to cattle, a person that guides, or drives, a herd of cattle from one place to another.

encrustation ∽ a solid or semisolid material attached to and forming a crust or coat on another surface.

estofado ∽ an artistic technique in which some surfaces of a sculpture are covered with gold leaf, after which the gold is painted over. Decorative patterns are then scratched or stamped into the paint to expose the gold.

fixative ∽ in art, a transparent liquid or spray applied to a painting or other artwork to prevent the smudging or fading of color or lines.

geometric design ∽ a design using straight lines and/or simple, regular shapes like triangles, squares, and circles.

gesso ∽ typically, a mix of plaster of Paris or gypsum with glue to make a thick liquid used to coat canvas or another surface as a base prior to painting.

gold leaf ∽ in art, a very thin foil of gold metal, typically applied to artworks for gilding, or in the lettering of illuminated books.

hematite ∽ the mineral form of iron oxide; a form of iron ore.

adobe ◦ *una mezcla de arena, arcilla, agua y paja o algún material fibroso similar, moldeado como ladrillo para la construcción.*

relieve arquitectónico ◦ *una obra de arte esculpida o un diseño que sale de una superficie plana como una pared o columna. Los tres tipos de relieve incluyen el bajorrelieve que se proyecta sólo ligeramente desde la superficie; el altorrelieve donde las figuras resaltan más de la mitad de su grosor tridimensional sobre su entorno; y el relieve hundido donde la imagen o diseño se talla en el mismo material de soporte (como si el objeto o diseño se prensara en una superficie suave).*

arriccio ◦ *enlucido o recubrimiento grueso preparado con cal y arena, que se usa como capa base debajo de un recubrimiento más fino aplicado para los murales al fresco.*

bruñir ◦ *dar brillo al frotar una superficie, usar una herramienta para pulir.*

conservador ◦ *en arte, una persona especializada que trabaja en el mantenimiento y restauración de obras de arte, artefactos y otros objetos valiosos.*

cornisa ◦ *moldura horizontal desde una superficie vertical; moldura que forma el remate superior de una pared.*

cúpula ◦ *una estructura arquitectónica en forma de la mitad superior de una pelota hueca, generalmente es un techo o parte del mismo.*

vaquero ◦ *una persona que guía o lleva al ganado de un lugar a otro.*

incrustación ◦ *un material sólido o semisólido unido para formar una costra o capa en otra superficie.*

estofado ◦ *técnica artística donde las superficies de una escultura se cubren con un baño de oro, después ésta se cubre con pintura. Los diseños decorativos se rascan en la pintura con un pequeño punzón donde se desea un color dorado.*

diseño geométrico ◦ *diseño donde se usan líneas rectas o formas sencillas y regulares como triángulos, cuadrados y círculos.*

gesso ◦ *generalmente es una mezcla de yeso de Paris con pegamento y agua para obtener un líquido grueso que se usa para cubrir los lienzos u otras superficies como preparación antes de pintar.*

laminado de oro, pan de oro, baño de oro ◦ *en arte, una lamilla muy delgada de oro, que generalmente se aplica a las obras de arte para dorar, o en las leyendas de libros antiguos decorados con oro y plata.*

intonaco ∽ a very fine coat of plaster spread on top of the rough coat to prepare a surface for a mural or other painting.

intonacino ∽ a final, third coat of extremely fine plaster to prepare a surface for a mural or other painting.

ledge ∽ in architecture, a narrow horizontal shelf or flat surface that projects from a vertical surface; a raised edge or molding.

monsoon ∽ a dramatic seasonal shift in winds that brings summer rains.

mucilage ∽ a thick, gummy substance used as a glue; also, a gummy substance produced by plants.

niche ∽ in architecture, a recess or hollow in a wall, typically made to display a statue or other decorative or honored item.

overpainting ∽ a coat of paint applied over an original painting in order to restore or improve a degraded image; or, a final coat applied in the painting of a mural or picture in which the first application of paint is intended to be temporary or built upon with further coats to enhance color or vibrancy, etc.

pigment ∽ in art, a substance, typically a powder, that is mixed with a liquid or gel to introduce color (or black or white) to paints, inks, and various other materials.

plaster ∽ a white cementlike material made of gypsum, lime, sand, and water used to coat walls, make casts, or build statues.

pouncing ∽ a stencil technique used to transfer drawings or patterns on paper to a hard surface; the lines of the drawing on paper are pricked with holes; the paper is then held against a wall, ceiling, or other surface while the holes are pressed upon with powdered charcoal to leave dots showing the lines of the drawing on the surface to be painted.

restoration ∽ in art, the return of an item to its original or former state (or reversing damage as much as possible) by cleaning, retouching, repainting, or other treatments.

Rhoplex™ ∽ a commercial product (a liquid acrylic binder) used in the primary coating of architectural surfaces.

scaffolding ∽ a temporary structure intended to support people and/or materials during the construction, decoration, or cleaning of another structure, like buildings.

tempera ∽ in art, a type of paint using egg yolk or other water-soluble substance to bind the pigment; also, a painting done with this type of paint, a type of painting most common from ancient times through the 1500s.

varnish ∽ a transparent, glossy coating usually applied to a painting, drawing, or other prepared surface as a liquid (or spray) that dries to a hard surface.

wainscot ∽ the lower three-to-four-foot band of an interior wall when it has a different color, surface, or treatment than the upper wall.

hematita ⌇ *la forma mineral del óxido de hierro; una forma de mineral de hierro.*

intonaco ⌇ *una capa muy fina de enlucido extendida sobre la capa gruesa para preparar una superficie para pintar un mural u otra pintura.*

intonacino ⌇ *la tercera y última capa de enlucido extra fino para preparar una superficie para un mural u otra pintura.*

repisa ⌇ *en arquitectura, un estante horizontal angosto o la superficie plana que se proyecta desde una superficie vertical; una moldura u orilla levantada.*

monzón ⌇ *un dramático cambio estacional del viento que trae lluvias de la estación.*

mucílago ⌇ *una sustancia pegajosa y gruesa usada como pegamento, también una sustancia gomosa producida por las plantas.*

nicho ⌇ *en arquitectura, un hueco o entrada en una pared hecho para colocar una estatua u otra pieza de respeto.*

repintado ⌇ *una capa de pintura aplicada sobre una pintura original con el fin de restaurar o mejorar una imagen deteriorada; o una capa final aplicada a un mural o cuadro donde la primera aplicación de pintura es temporal o parte de la preparación con más capas para realzar el color o brillo, etc.*

pigmento ⌇ *en arte, una sustancia, típicamente un polvo, que se mezcla con un líquido o gel para introducir color (o blanco o negro) a las pinturas, tintas y otros materiales.*

enlucido, encalado ⌇ *un material blanco hecho de yeso, cal, arena y agua para recubrir paredes, hacer moldes y construir estatuas.*

estarcido ⌇ *una técnica de copiado usada para pasar los dibujos o diseños en papel a una superficie dura; las líneas del dibujo en papel se perforan con un punzón; después el papel se coloca sobre la pared, techo o cualquier superficie y con un saquito lleno de polvo de carbón se golpea sobre los agujeros, punteando las líneas del dibujo en el área que se quiere pintar.*

restauración ⌇ *en arte, restituir una pieza a su estado original o anterior (o revocar el daño tanto como sea posible) por medio de la limpieza, retocado, repintado u otros tratamientos.*

Rhoplex™ ⌇ *un producto comercial (adhesivo acrílico) usado en el revestimiento base de las superficies arquitectónicas.*

andamio ⌇ *una estructura provisional, levantada del suelo que sirve para sostener a los obreros y materiales durante la construcción, reparación o limpieza de un edificio.*

pintura al temple ⌇ *en arte, un tipo de pintura que usa la yema de huevo u otra sustancia soluble en agua para aglutinar el pigmento; también el arte hecho con este tipo de pintura, este tipo de pintura fue común en la antigüedad hasta 1500.*

barniz ⌇ *un revestimiento transparente, generalmente brillante que se aplica a las pinturas, dibujos u otras superficies como liquido (o spray) que se seca endureciéndose.*

friso o cenefa ⌇ *la franja más baja (1 a 1.2 m de alto) de un muro o pared interior cuando tiene un color, superficie o tratamiento diferente de la parte superior.*

Afterword / *Epílogo*

MORE ON THE ART OF THE MISSION SAN XAVIER DEL BAC

We hope we have whetted your appetite for exploring the magnificent art and fascinating story of our Sonoran Desert treasure, the Mission San Xavier. If so, we encourage you to look for the definitive work on its art, *A Gift of Angels: The Art of the Mission San Xavier del Bac*, by Bernard L. Fontana. The 350-odd oversized pages of this hardcover book boast truly extraordinary photographs by Edward McCain, and the accessible texts by Dr. Fontana explain in detail not only the artworks, their sources, and references, but also the saints themselves, in a way that brings together their beauty, their history, their humanity, and their divinity. *A Gift of Angels* is published by the University of Arizona Press, © 2010, Tucson, Arizona; ISBN 978-0-8165-2840-0.

MISSION SAN XAVIER DEL BAC TODAY

While this masterpiece of Spanish colonial architecture and lavish baroque art is a National Historic Landmark welcoming visitors from around the world, it is also an active Catholic parish. It serves the local Tohono O'odham community in much the same way it did nearly two centuries ago with baptisms, weddings, and other church functions. Visitors and pilgrims are welcome to attend daily or Sunday masses and special celebrations.

Every December, the nonprofit organization Patronato puts on a series of Christmas concerts with secular and sacred music in the San Xavier church, the profits from which support ongoing preservation projects there.

Concert dates, details, and ticket information are announced in the fall for the following Christmas season through a blog link at the Patronato website, *www.patronatosanxavier.org*. This site also provides information on the ongoing restoration and conservation work. For more information about mission hours and events go to *www.sanxaviermission.org*.

Just southwest of downtown Tucson, the mission is open to the public daily, free of charge, and offers regularly scheduled tours by docents knowledgeable about its art and history. We encourage you to visit and explore the White Dove of the Desert, as it is known locally.

While you are in the Tucson area, we hope you will also visit us at the Arizona-Sonora Desert Museum to learn about and enjoy the unusual creatures and plants of the region. Go to our website at *www.desertmuseum.org* for information about this world-class zoo, botanical garden, natural history museum, art institute, research center, and more.

MÁS SOBRE EL ARTE DE LA MISIÓN DE SAN XAVIER DEL BAC

Esperamos haber abierto el apetito y la curiosidad para que usted explore el magnífico arte y la fascinante historia de nuestro tesoro en el Desierto Sonorense, la Misión de San Xavier. De ser así, le invitamos a buscar el libro de mayor autoridad en su arte, A Gift of Angels: The Art of the Mission San Xavier del Bac de Bernard L. Fontana. Este libro monumental de pasta dura y más de 350 páginas cuenta con fotografías verdaderamente extraordinarias tomadas por Edward McCain. Y el texto sencillo del Dr. Fontana explica en detalle no sólo las obras de arte, sus fuentes y referencias, sino también los mismos santos, de tal forma que junta su belleza, su historia, su humanidad y su divinidad. A Gift of Angels lo publica The University of Arizona Press, © 2010, Tucson, Arizona; ISBN 978-0-8165-2840-0.

LA MISIÓN DE SAN XAVIER DEL BAC EN LA ACTUALIDAD

Aunque esta obra maestra de arquitectura colonial española y espléndido arte barroco es un Monumento Histórico Nacional que recibe visitantes de todo el mundo, también es una parroquia católica activa. Sirve a la comunidad Tohono O'odham tal y como sucedía hace cerca de dos siglos con bautismos, bodas y otros servicios religiosos. Los visitantes y peregrinos, si gustan participar, pueden asistir a la misa diaria o dominical y otras celebraciones.

Cada diciembre, el Patronato, una organización no lucrativa, ofrece una serie de conciertos navideños con música sacra en la iglesia de San Xavier y las utilidades que se reciben son para los proyectos de restauración. La fecha de los conciertos, venta de boletos y otros detalles se publican en el otoño, previo a la temporada navideña, en el portal del Patronato, www.patronatosanxavier.org. Este portal también proporciona información sobre proyectos de restauración actuales y las obras de conservación. Para mayor información sobre horarios y eventos visite www.sanxaviermission.org.

Justo al suroeste del centro de Tucson, la misión está abierta diariamente al público, sin costo alguno y regularmente ofrece recorridos guiados por docentes conocedores de su arte e historia. Le invitamos a que visite y explore la Paloma Blanca del Desierto, como se le conoce en la región.

Cuando esté en el área de Tucson, esperamos que también nos visite en el Museo del Desierto Arizona-Sonora para aprender y disfrutar con las inusuales criaturas y plantas de la región. Visite nuestro portal en www.desertmuseum.org para información sobre este importante zoológico, jardín botánico, museo de historia natural, instituto de arte, centro de investigación y mucho más.

Acknowledgments / Agradecimientos

CRAIG S. IVANYI, *Executive Director / Director General*
ROBERT J. EDISON, *Executive Philanthropy Director / Director de Filantropía*
LINDA M. BREWER, *ASDM Press Manager / Directora de la Editorial ASDM*

The Desert Museum is deeply grateful to Dr. Bernard L. Fontana for his early review of the narrative and texts in *Mission San Xavier: A Story of Saints and Angels, Art and Artists.* As the preeminent scholar of the Mission San Xavier and an active participant in its conservation, Dr. Fontana has an unequaled breadth and depth of knowledge on these subjects. His thoughtful review provided us with invaluable guidance and correction. His richly illustrated and magnificently written tome, *A Gift of Angels: The Art of Mission San Xavier del Bac,* also provided us with an important up-to-date reference.

We are also sincerely grateful to Desert Museum supporters who generously sponsored the publication of *Mission San Xavier,* including Charles & Patricia Pettis, Fred & Mary Frelinghuysen, Joan Robles, Pat Raskob & Tom Paulus, Peter Salomon & Patricia Morgan, Harry George & Cita Scott, and Arch & Laura Brown. We would also like to acknowledge the kind assistance of Dale Brenneman and the board of the Southwest Missions Research Center at the University of Arizona. We are also grateful to Helen Lazo for allowing us to reproduce the painting of the main altar of the church. Additionally, this book has benefited significantly from the vision of Richard C. Brusca, former director of the Arizona-Sonora Desert Museum Press; the creative inspiration of Terry Moody, a gifted graphic designer; and the translation skills of Ana Lilia Reina-Guerrero. Edna San Miguel's experiences with the international conservation team, her superlative talents, and great spirit are, of course, the foundation of this publication. Her splendid artistic interpretations of the statuary and decorations of the Mission San Xavier honor the original artwork within the church.

El Museo del Desierto le agradece profundamente al Dr. Bernard L. Fontana su revisión de la narración y texto en La Misión de San Xavier: Una Historia de Santos y Ángeles, Arte y Artistas. *Como la suprema autoridad de la Misión de San Xavier y un activo participante en su conservación, el Dr. Fontana cuenta con un amplio y profundo conocimiento de estos temas. Con su revisión cuidadosa nos proporcionó una orientación y corrección invaluables. Su libro magníficamente escrito e ilustrado:* A Gift of Angels: The Art of Mission San Xavier del Bac, *también nos sirvió como una referencia actualizada.*

Del mismo modo estamos sinceramente agradecidos con los patrocinadores del Museo del Desierto que generosamente apoyaron la publicación del libro de la Misión de San Xavier, *entre ellos Charles & Patricia Pettis, Fred & Mary Frelinghuysen, Joan Robles, Pat Raskob & Tom Paulus, Peter Salomon & Patricia Morgan, Harry George & Cita Scott, y Arch & Laura Brown. Así mismo queremos agradecer la asistencia de Dale Brenneman y el consejo directivo del Southwest Missions Research Center en la University of Arizona. Agradecemos a Helen Lazo el permitirnos reproducir la pintura del altar mayor de la iglesia. Por otra parte, este libro contó con la visión de Richard C. Brusca, director anterior de la editorial del Arizona-Sonora Desert Museum; la inspiración de Terry Moody, una talentosa diseñadora gráfica; y la experiencia en traducción de Ana Lilia Reina-Guerrero. La experiencia de Edna San Miguel con el equipo internacional de restauración, su talento excepcional y su gran entusiasmo por supuesto son la base de esta publicación. Sus espléndidas interpretaciones artísticas del estatuario y las decoraciones de la Misión de San Xavier respetan las obras de arte originales de la iglesia.*